Great
SMOKY MOUNTAIN
impressions

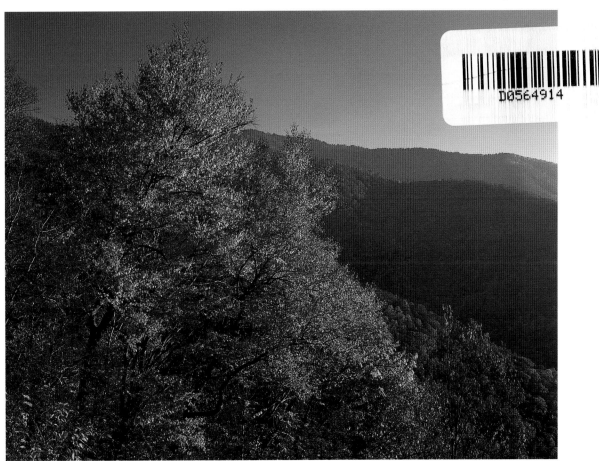

Photography by George Humphries Text by Steve Kemp

FARCOUNTRY
PRESS

Dedication

To my wife Linda and my children
Katie, Sean and Weston.

RIGHT: A wet snow weighs on the branches of Eastern hemlock trees and coats boulders in the Little Pigeon River. Over 2,000 miles of rivers and streams course through the Great Smoky Mountains.

TITLE PAGE: Newfound Gap in autumn. A gap in southern Appalachian vernacular is a low point in a ridge or mountain chain. In the Northeast it would be called a notch, in the West a pass.

FRONT COVER: Big Creek features many scenic waterfalls and cascades, including Mouse Creek Falls and Midnight Hole.

BACK COVER: View from the Appalachian Trail near Clingmans Dome. The evergreen spruce-fir forest that caps the Appalachian Mountains reaches the southern extent of its range in Great Smoky Mountains National Park.

ISBN: 1-56037-206-0
Photographs © 2002 by George Humphries
Text © 2002 by Steve Kemp
© 2002 Farcountry Press

Created, produced, and designed in the United States.
Printed in Korea

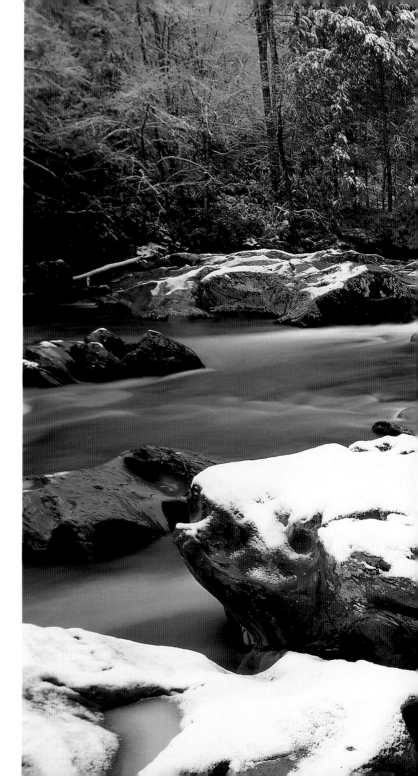

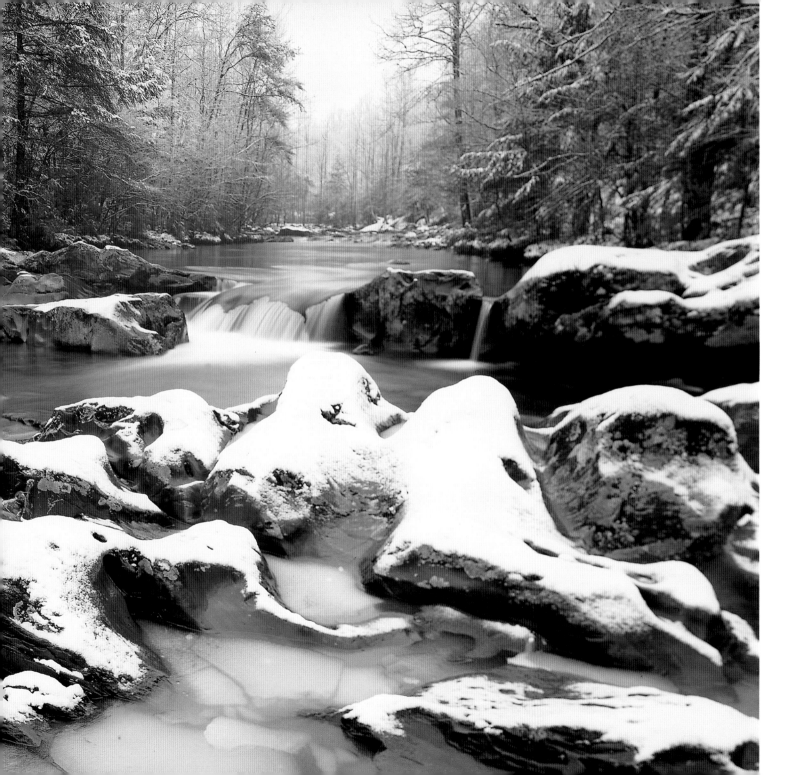

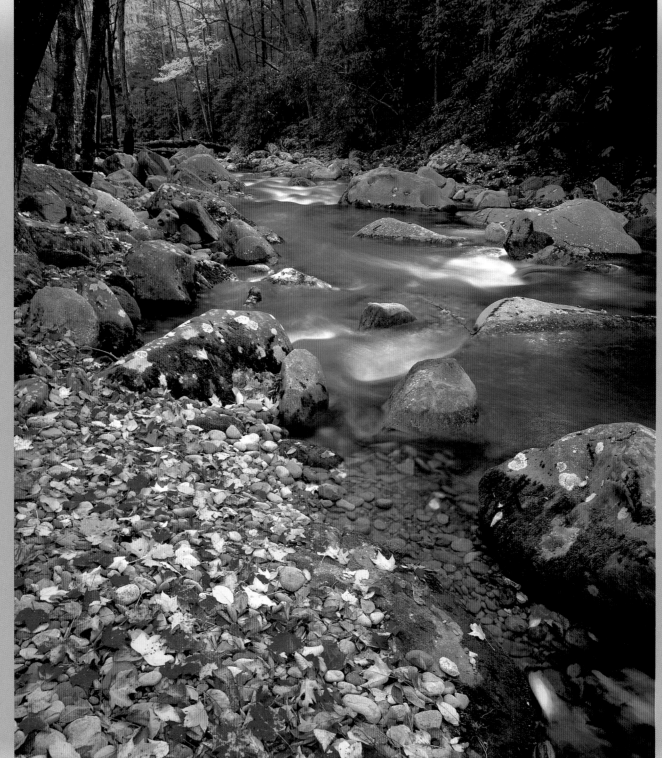

Maple and tulip-tree leaves line the bank of the Middle Prong of the Little Pigeon River in October. The Ramsay Cascade Trail follows the stream along part of its course through the Greenbrier area of the national park.

Jagged and forbidding are not words you would choose to describe the Great Smoky Mountains. Though impressive, even majestic, the 6,000-foot-tall Great Smokies are gentle compared to younger mountain ranges. Time has sculpted the high peaks into domes, long arching ridges, and rounded summits that are somehow hospitable and welcoming. In the grand, geographical scheme of things, the Smokies might be considered the warm maternal hug of mountain ranges.

What makes the Great Smoky Mountains spectacular is their living, verdant skin. The lush forests, shrubby thickets, and highland meadows that cloak the ancient Smokies form a vital mosaic of ever-changing beauty.

Take spring, for example. Even before the hardwood trees unfurl their leaves, a riot of wildflowers paints the cool, damp forest floor in an exquisite palette of colors. There are phlox blues, fire pink reds, trout lily yellows, Jack-in-the-pulpit greens, and acres of bridal whites complement fringed phacelia.

In summer, the forests of the Smokies are at the height of their power. A billion leaves are turned toward the sun, absorbing carbon dioxide and producing oxygen. Orange, yellow, and red flame azaleas bloom on the grassy balds while mile-high ridges are painted rose and lavender by sweeping expanses of rhododendron. Brightly feathered wood warblers, the so-called "jewels of the forest," seem to sing from every grove and bramble.

Even though Great Smoky Mountains National Park is quite a bit smaller than its Western brethren (Yellowstone is about four times its size), the Smokies shelter a greater variety of flowering plants than any other North American

Foreword

by Steve Kemp

national park—around 1,600 different taxa. It can also boast more different types of native trees than all of northern Europe (99 species) and a greater diversity of salamanders than any other similar-sized natural area on Earth.

So rich are the Great Smokies that some species of plants and animals live there and nowhere else. Rugel's ragwort, a robust wildflower, is abundant at the higher elevations of the Smoky Mountains but has never been found beyond the park's boundaries. The same is true of Jordan's salamander, a five-inch-long, red-cheeked amphibian entirely indigenous to the mountain range. Some ridgelines in the Great Smokies support varieties of beetles that are genetically distinct from the same species living just across the valley.

Accompanying diversity are abundance and grandeur. At last count, over 1,500 black bears inhabited the national park, a density approaching two bears per square mile. Compare this to one black bear per three miles in California's Yosemite National Park and you begin to understand how fruitful the Smoky Mountain ecosystem is. Bears are eating machines that must add layer upon layer of fat to their bodies during the warmer months in order to endure their long winter fast. They need insects, meat, and lots and lots of berries in summer, then acorns, beech nuts, and wild

A luscious parade of wildflowers blooms from February through November in the Great Smoky Mountains.

grapes in autumn. During a good acorn year in the Smokies, some bears find so much food they remain active into December.

The park's virgin forests are showcases of vigorous abundance. Although only about 20 to 25 percent of the forests in the Smokies were spared the farmer's plow and logger's saw, they still represent a majority of the eastern United States' old-growth forest. Better than a dozen species of trees reach record size in these woodlands, including giants like the red maple, yellow buckeye, red spruce, eastern hemlock, and northern red oak. White pines over 200 feet tall have been measured, and researchers recently documented hemlock and blackgum trees over 400 years old.

In the 2,000 miles of streams and rivers that tumble from the Smoky Mountain high country, over fifty species of fish find homes. New varieties of aquatic insects such as caddisflies and mayflies are discovered by scientists every year. Estimates of total aquatic insect diversity in the park are upwards of 1,500 species. Some may be unique to a single spring, cave, or watershed.

Why is life so varied and successful in the Smokies? Most important are the mountains. Along the tops of the Great Smokies, at better than a mile above sea level, temperatures are similar to those in the lowlands of New England and southeastern Canada. The forest is a dark, sweet-scented world of spruce, fir, and American mountain-ash trees, similar to boreal forests 1,000 miles to the north.

Inhabiting these highlands are northern denizens like Blackburnian warblers, blue-headed vireos, least weasels, northern flying squirrels, red squirrels, veerys, black-capped chickadees, and, a century or so ago, fishers and gray wolves. Frost has been noted on Clingmans Dome in August, and flurries of snow can be counted on in October.

In contrast, the lush river valleys of the lowlands are an

entirely different world. Many of the trees are familiar to visitors from Dixie, even those arriving from Atlanta, Birmingham, and Jackson. Bigleaf magnolia, shortleaf pine, post oak, winged elm, southern red oak, sweetgum, and persimmon grow among the lower slopes and foothills of the Smoky Mountains. Dyed-in-the-wool Southern fauna like the green anole, southeastern five-lined skink, rough green snake, black vulture, and Carolina chickadee are perfectly at home on the sunny south-facing slopes and in the old farm fields. The mockingbird, state bird of both Florida and Mississippi, can be heard singing on the same May morning in Cades Cove when the black-capped chickadee (state bird of Maine) calls chick-a-dee-dee-dee from atop 6,593-foot Mount Le Conte.

Between the high peaks and warm lowlands are other rich and interesting habitats which, within the realm of a fifteen-minute drive, may remind the traveler alternately of Pennsylvania, Wisconsin, and Arkansas. On the left, a steep ravine is crowded with moisture-loving hemlocks and rhododendron while on the right, pines, oaks, and mountain laurel bask in the hot afternoon sun. Out along the ridgetop, rhododendrons grow so tightly packed few trees can gain a toe-hold.

For many, the Taj Mahal of park ecosystems is the cove hardwood forest. Nowhere else in North America does a broad-leaved woodland reach such a climax. Named for the sheltered, damp, deep-soiled valleys where it thrives, the cove hardwood forest is remarkable both for the mammoth size of its trees and the tremendous variety of its flora and fauna.

A single acre of this forest may harbor twenty species of native trees and forty kinds of wildflowers. Tuliptrees reach fifteen stories or more skyward and sugar maples grow to twenty feet in circumference. Black bear, bobcat, skunk, raccoon, southern flying squirrel, gray fox, pileated woodpecker, and other animals find a horn of plenty here. There are scores of trees that would be of incredible value to lumbermen and furniture makers—

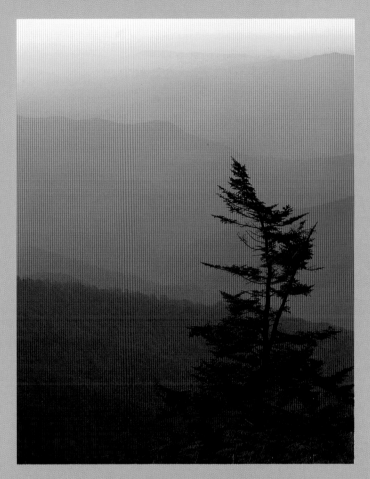

Sunset from the Appalachian Trail near its high point at Clingmans Dome (6,643 feet). Seventy of the trail's 2,100 miles run through Great Smoky Mountains National Park.

black cherry, black walnut, white oak, basswood, red maple—were they not protected in a national park. When such cove hardwood forests reach their mature form, they are sometimes called by another name: green cathedrals.

Aside from the variety of habitats created by elevation and aspect, diversity in the Smokies has climate to thank. Along the

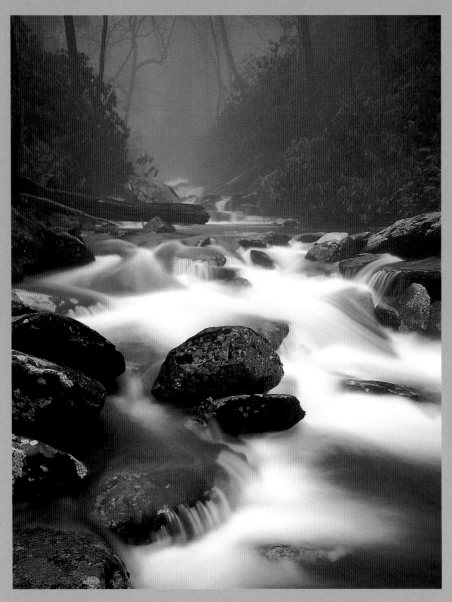

Clear-running mountain streams, fog, and ethereal mist typify the Great Smoky Mountains. The range is named for the smoke-like wisps of cloud and blue haze that are often present, especially after a rain.

high peaks, some seven feet of water, in various forms, are deposited in a year. Even in the foothills, fifty-five inches can be counted on, eighteen inches more than famously soggy Seattle. The Smokies' pervasive summertime humidity, though oppressive to most humans, is an absolute boon to plants. Humidity decreases water loss in flora, allowing them the luxury of unhindered growth.

Even Earth history has favored abundance and variety in the Great Smoky Mountains. For over 300 million years, life has gone on without interruption from inundating seas or other cataclysms. During the 1.6-million-year-long Pleistocene Ice Age, glaciers never reached as far south as the Smokies. As periods of cold alternated with warm, both northern and southern species were forced southward or northward to the Smokies. Plants and animals from the far north relocated to the high Smokies where permanent snowfields and alpine meadows dominated.

During interglacial warm-ups, some which were drastic, semi-tropical species migrated to places like Cades Cove. When the climate moderated 10,000 to 12,000 years ago, some plants and animals stayed on, finding sanctuary in the Smokies. From this ark, life spread to the north and west, repopulating glacier-scoured lands.

Geologically, the Great Smoky Mountains are most impressive for their age. The pulverized and baked sandstone that makes up much of the range is at least 600 million years old. Some of

the granite around Deep Creek Campground has been around for a billion years. Except for limestone areas like Cades Cove and Chilhowee Mountain, rock in the Smokies predates most hard-bodied life on Earth—it is virtually fossil-less.

Despite millions of years of wear and tear from water and ice, the Great Smokies are still some of the tallest mountains east of the Mississippi River. Clingmans Dome, the highest peak in the Smokies, and third-highest in the East, is only forty-one feet shorter than North Carolina's Mount Mitchell, the highest eastern summit. A hiker can follow the Appalachian Trail for twenty miles in Great Smoky Mountains National Park and never dip below 5,000 feet in elevation. Perched atop 6,593' Mount Le Conte, a rustic lodge offers the highest overnight accommodations in the East.

Elevation, ruggedness, remoteness, and dense vegetation caused the Great Smokies to be avoided or circumnavigated by humans for thousands of years. Native Americans settled along the outskirts of the mountains, but only penetrated the interior on limited hunting and gathering trips, or passed through on their way to somewhere else. European explorers from Hernando de Soto to William Bartram came near, but probably never entered the boundaries of what is today Great Smoky Mountains National Park. When Lewis and Clark reached the Pacific Ocean in 1806, only a handful of people of European descent inhabited the periphery of the Smokies, and settlement of

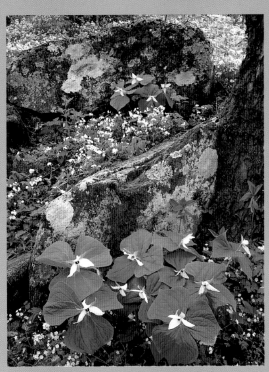

Trillium and fringed phacelia cover a boulder and the forest floor. Over 1,500 species of vascular plants live in the Smokies, more than in any other North American national park.

Cades Cove would not begin for more than a decade.

When farmers did begin buying up land in the valleys and lower slopes of the Smokies in the early to mid–19th century, most were courageous and hardy individualists more interested in privacy and freedom than comforts and wealth. By some standards they were poor and under-educated, but most could convert a stand of tuliptrees into a furnished home using only a handful of woodworking tools and the help of a neighbor or two.

Hardly an acre of land could be planted until it was first cleared of towering hardwoods and boulders as large as fattened hogs. But Smoky Mountain farmers were nothing if not resourceful and persistent. Eventually they did fill their corncribs, smokehouses, and spinghouses. In late summer and fall, the men went off for days or weeks at a time to hunt bear, deer, squirrel, raccoon, woodchuck, mountain lion, and other game. They filled stringers with wild brook trout from crystal clear prongs and branches. Families harvested a half dozen varieties of berries and gathered bushels of chestnuts that could be traded in town for cash. Taking their lead from the Cherokee, they gathered bark, twigs, and greens for teas, spices, medicines, and basketmaking. No doubt life was difficult and sometimes filled with sorrow, but their level of self-reliance and self-determination was something that many Americans look back on longingly today.

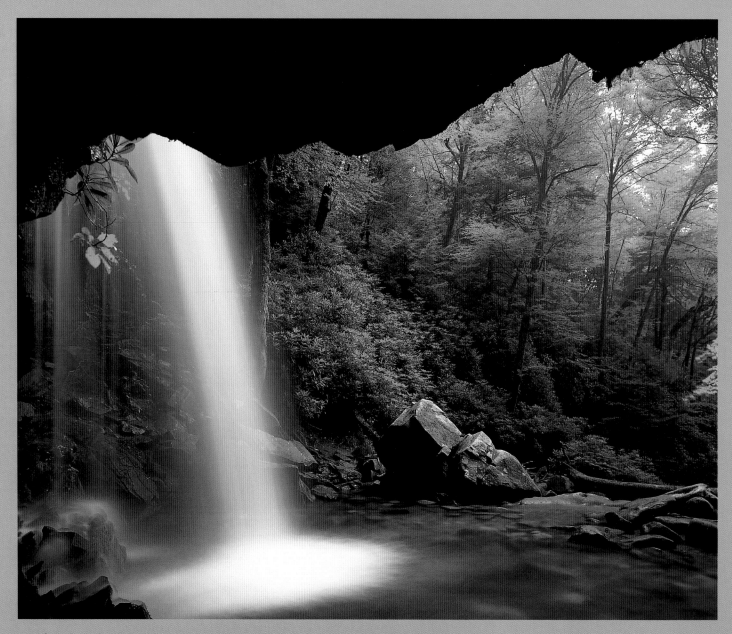

View from the grotto behind Grotto Falls. The popular 1.5-mile hike to the waterfall begins at Roaring Fork Motor Nature Trail.

Things became a lot more modern for mountain folk around 1900 when the big logging companies got down to business in the Smokies. For the first time, many men quit growing and shooting their livelihood and started working for wages. With local sawmills churning out thousands of board feet of lumber each day, framed houses replaced the old log domiciles. Railways and roads brought towns like Knoxville, Tennessee, and Waynesville, North Carolina, much closer.

Ironically, it was the environmental devastation wrought by industrial-strength logging that mobilized some of the forces that eventually created Great Smoky Mountains National Park. Author and outdoorsman Horace Kephart wrote in 1925:

"Here stands today, in the Great Smoky Mountains, the last hundred square miles of uncut primeval forest, just as it stood, save for added growth, when Columbus discovered America. It will all be destroyed within ten or fifteen years if the Government does not take it over and preserve it intact so that future generations may see what a genuine forest wilderness is like."

Local businesspeople and civic boosters also cried out for establishment of a national park, but for different reasons. They envisioned waves of tourists carried by shiny new automobiles spending fistfuls of dollars at area hotels, restaurants, and shops.

Obstacles to creating an 800-square-mile national park out of land that was entirely in private hands were more than daunting. The ten different lumber companies that owned much of the mountain land were bitterly opposed to the park, and lobbied elected officials and the public relentlessly to halt the movement. In the fertile river valleys, up the narrow hollows, and in the boomtown lumber camps, more than 4,000 people had made their homes. Some jumped at the chance to take the money the state governments were offering to move to more fertile grounds. Others were shocked and angered—they loved the land and their communities forged over three or more gen-erations. In places like Cataloochee, Oconaluftee, and Cades Cove, some families had achieved relative prosperity and many felt they weren't being fairly compensated for their homes and land.

The battle between pro- and anti-park forces raged for eleven years. Those favoring the park had not only a political fight to win, but also a financial one. Because of the politically sensitive

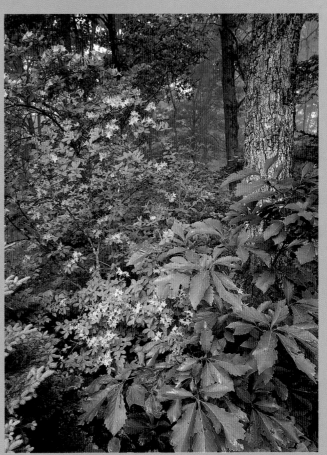

Flame azalea and rosebay rhododendron in early summer along Rainbow Falls Trail. Naturalist/explorer William Bartram dubbed flame azalea "the most gay and brilliant flowering shrub yet known."

nature of land acquisition, the bulk of the money to purchase the land had to come from private rather than public funds. Over $10 million had to be raised, much of it after the American economy collapsed into depression in 1929. School children gave pennies, corporations and individuals gave thousands, and the Laura Spelman Rockefeller Foundation gave $5 million. In 1934, Congress set aside nearly the entire length and breadth of the Great Smoky Mountains as a national park to be preserved in perpetuity "for the benefit and enjoyment of the people."

Despite the difficulty of its birth, nearly all agree today that the park is a magnificent success. Some 100,000 acres of virgin forest were spared the saw and continue to flourish under park protection. For those hundreds of families that were uprooted from their mountain homes, there is some consolation. They and their descendants can return to their family homesites and see the same wildflower-laden glens and far-flung mountain vistas that attracted their forefathers 175 years earlier. Millions upon millions of tourists have shown up in their shiny automobiles and spent their vacation dollars, boosting the fortunes of many property owners and businesspeople.

The big winners though have been the American people. The 520,000 acres that are Great Smoky Mountains National Park are public land, open 365 days per year, a Mecca for hikers, nature lovers, and sight-seers of all kinds. The Great Smoky Mountains are not owned by one or by several, but by all.

Late autumn colors from Newfound Gap Road looking toward the Oconaluftee River Valley. Few places in the world can rival the fall color displays in the Appalachian Mountains.

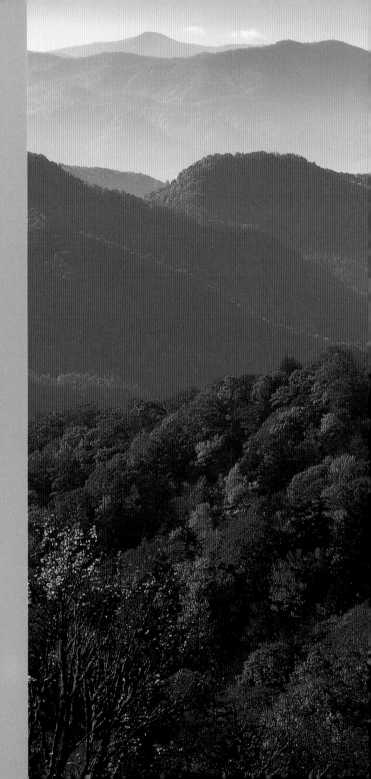

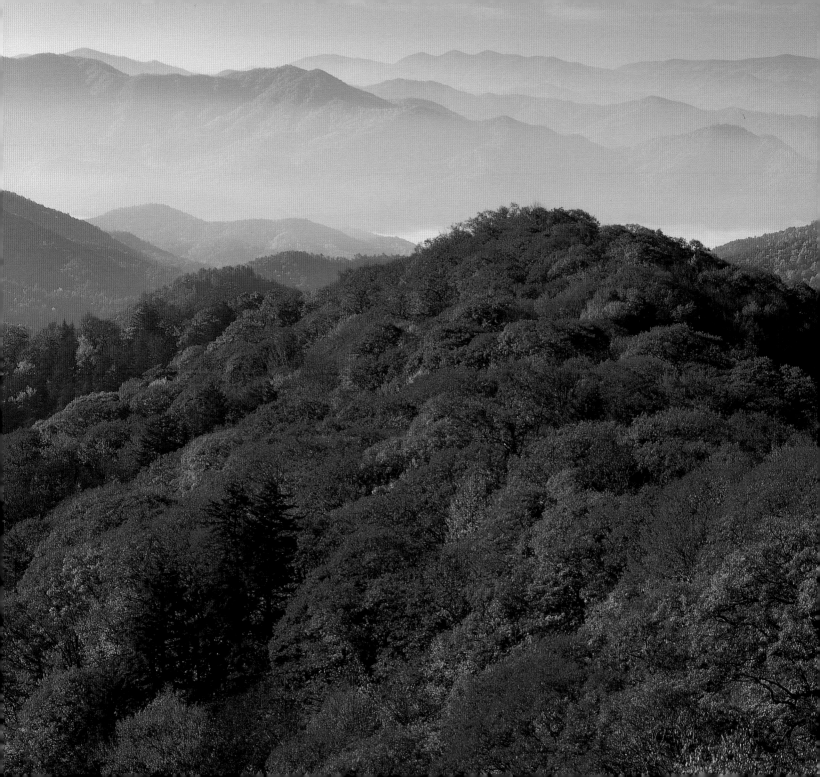

RIGHT: With an average annual rainfall of 85 inches along the peaks, and high summertime humidity, the Great Smoky Mountains qualify as a temperate rain forest. Mosses, ferns, lichens, and other plants thrive in these moist, moderate conditions.

FACING PAGE: Mountain laurel blossoms mark the transition from spring to summer. The hearty evergreen shrub is abundant almost everywhere in the park below elevations of 5,000 feet.

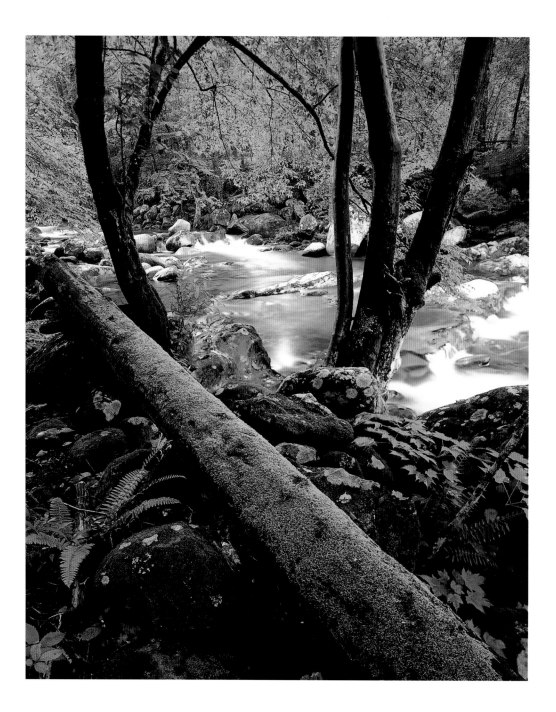

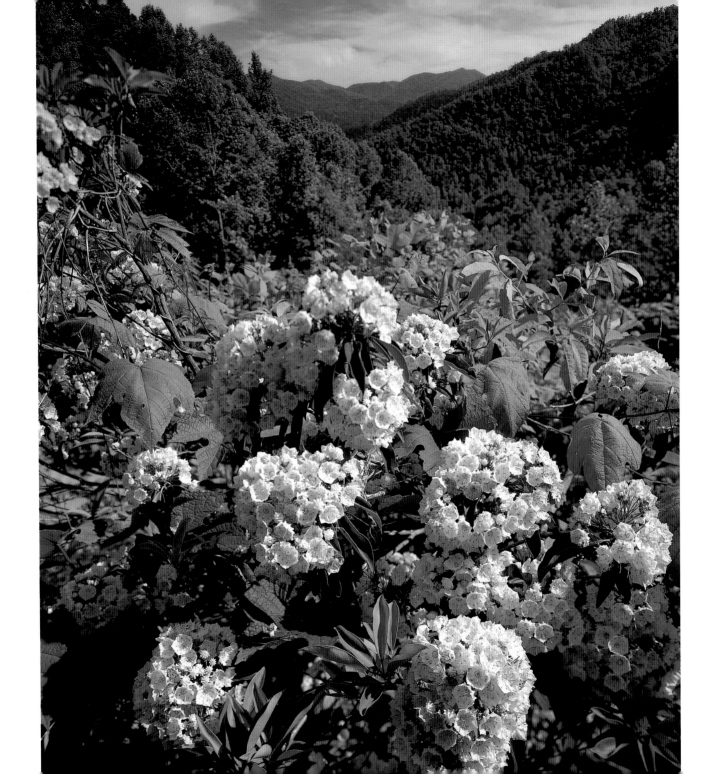

RIGHT: Cascading Road Prong splashes past a jungle of rhododendron. The stream is named for the old wagon road which used to be the main thoroughfare across the Smoky Mountains.

FACING PAGE: Maple and sourwood trees frame an autumn view of the Great Smoky Mountains from the Foothills Parkway. Both the eastern and western segments of the parkway are good places to view fall colors.

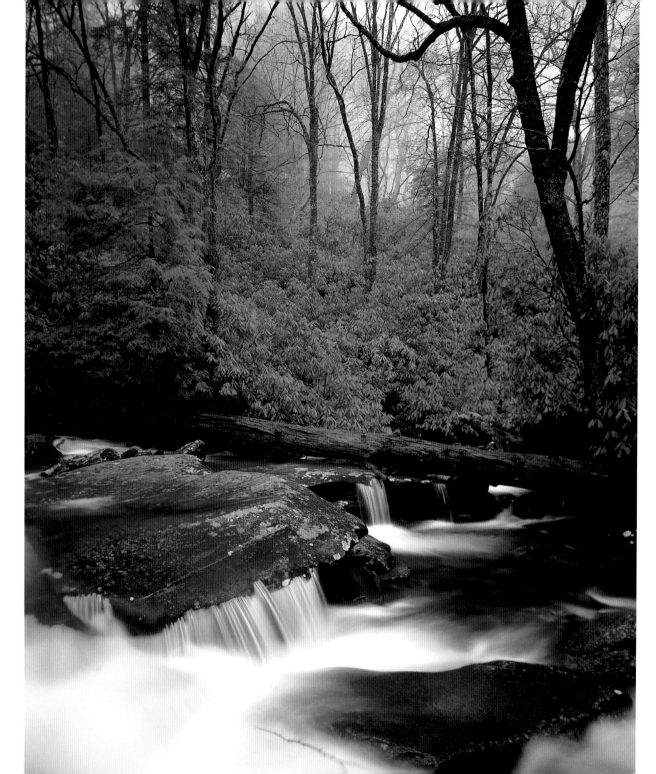

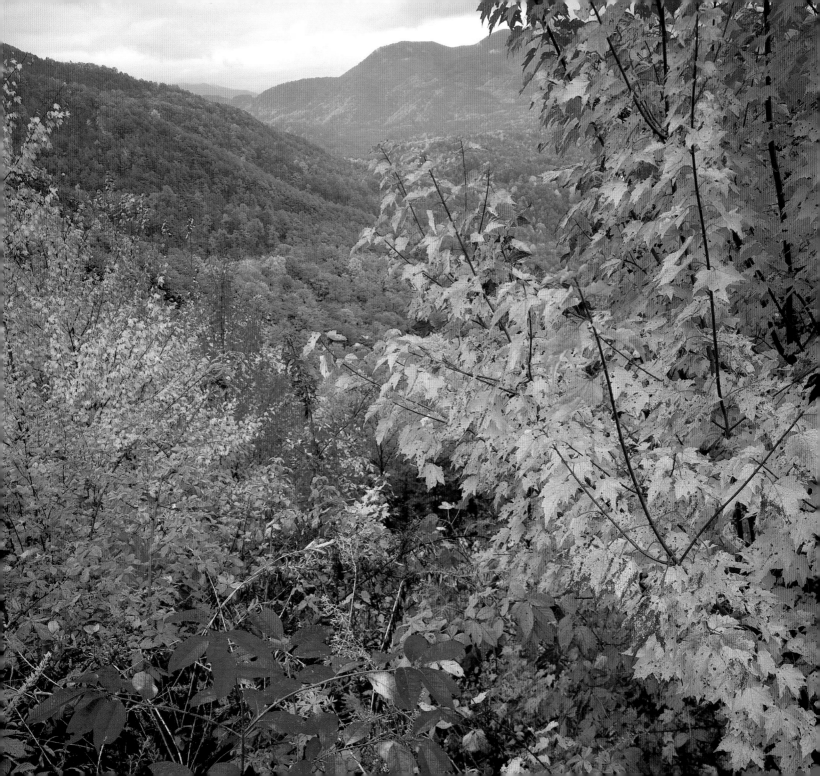

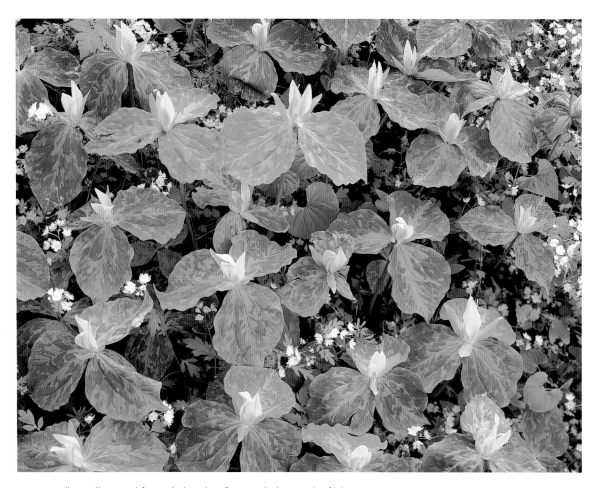

ABOVE: Yellow trillium and fringed phacelia often reach their peak of bloom in mid-April. All trilliums have three leaves and their flowers have three petals and three stigmas.

FACING PAGE: The Little River in spring. The relatively easy Little River Trail follows this picturesque stream for approximately six miles.

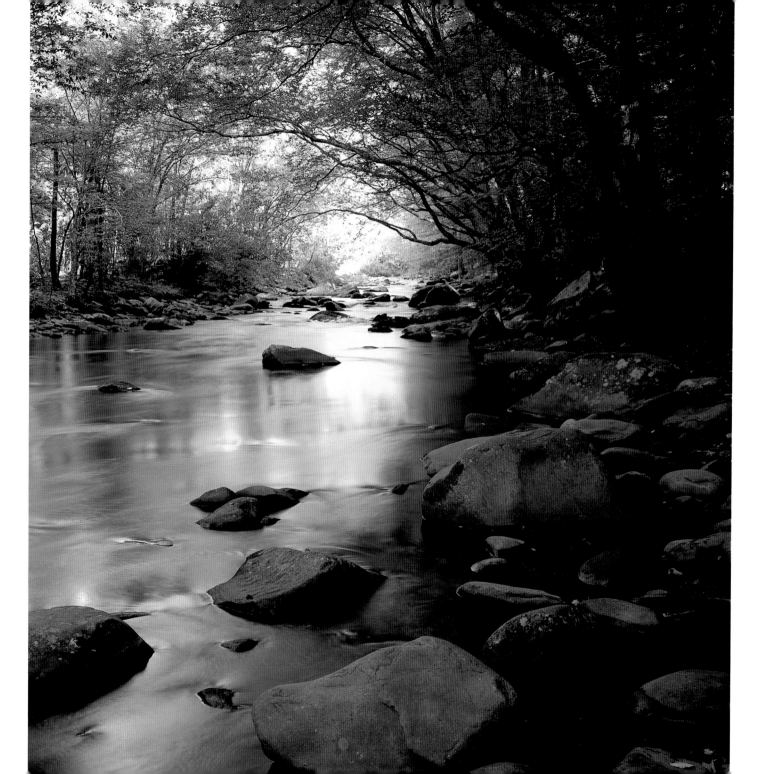

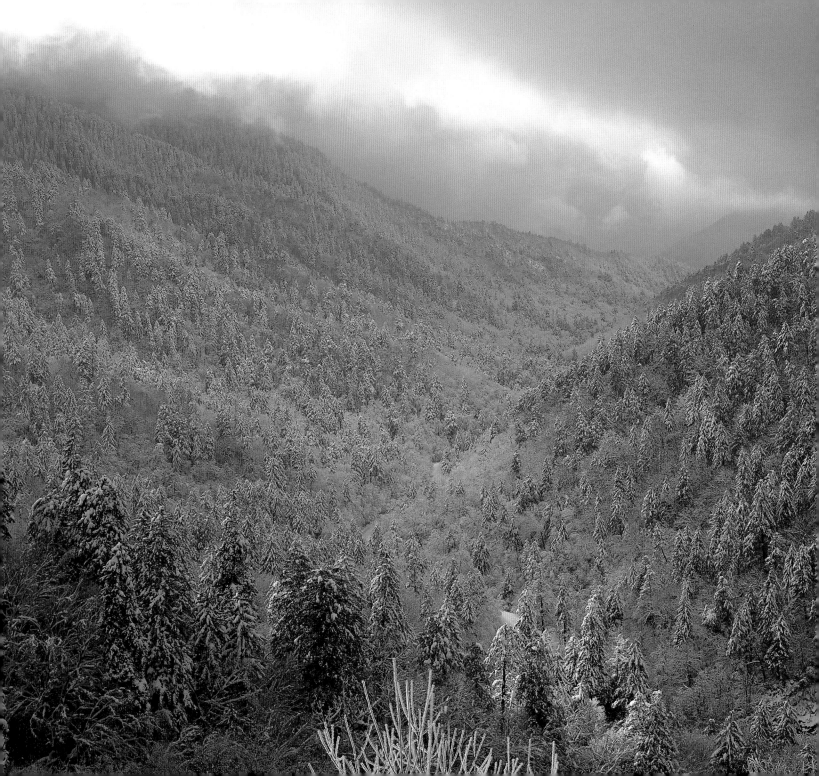

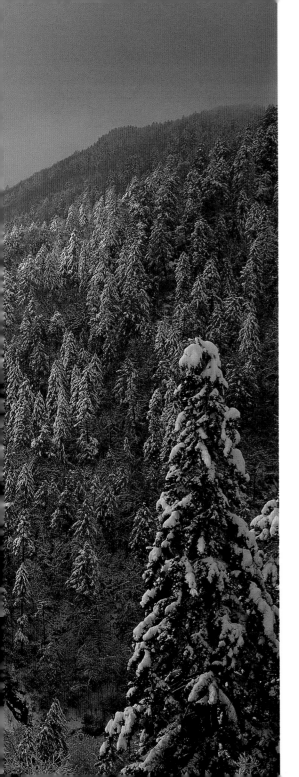

ABOVE: Ice covered berries of an American mountain-ash tree. The mountain-ash is a northern species that reaches the southern edge of its range in the Great Smoky Mountain high country.

LEFT: Snow may fall in the high country any time from October through April. High elevation spruce and fir trees are well adapted to shed heavy snow.

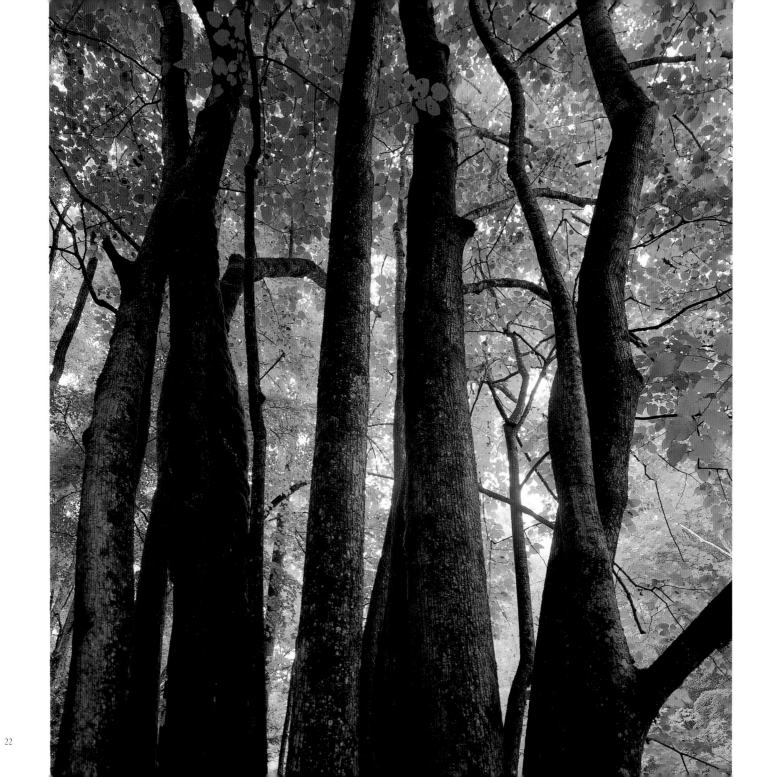

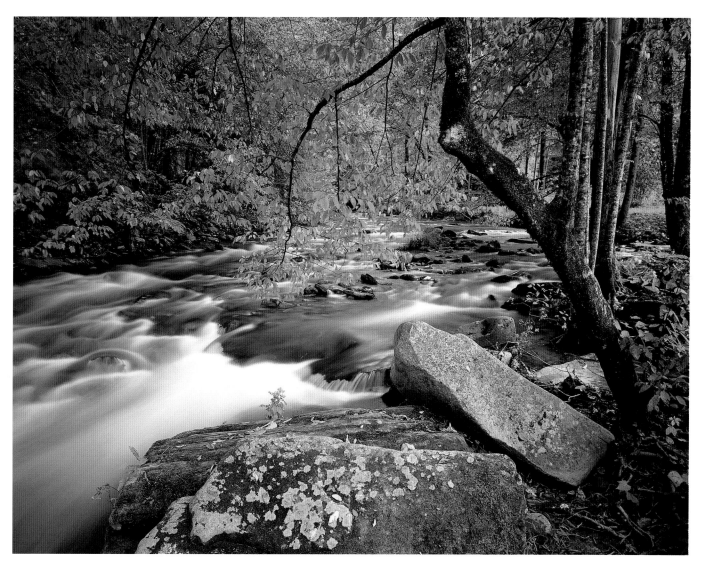

ABOVE: The Oconaluftee River in late summer. Oconaluftee is a Cherokee name which means "by the river." Like other park streams, the Oconaluftee is open year-round to licensed anglers. Large rainbow and brown trout ply its swift waters.

FACING PAGE: The Middle Prong of the Little Pigeon River is lined by moisture-loving trees such as sycamore, basswood, black birch, and ironwood.

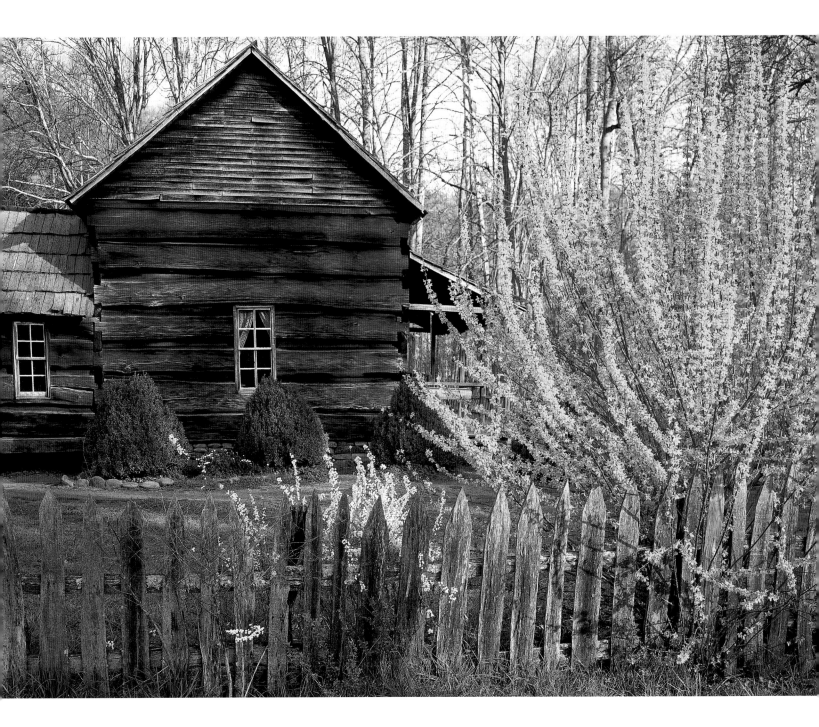

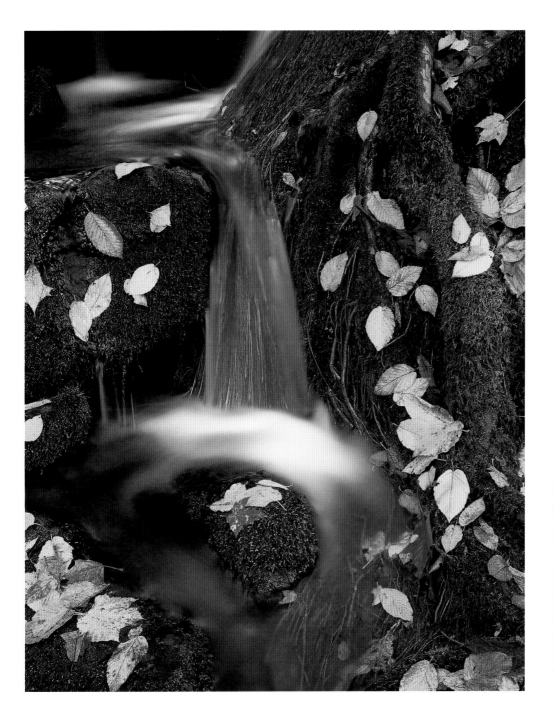

LEFT: Water flows over the thirsty roots of a large sycamore tree. During winter, leaves that collect in streams are consumed by aquatic insects and microorganisms.

FACING PAGE: Forsythia blooms in early spring at the Oconaluftee Mountain Farm Museum near Cherokee, North Carolina. The open-air museum features a variety of historic buildings gathered from old farms throughout the Great Smoky Mountains.

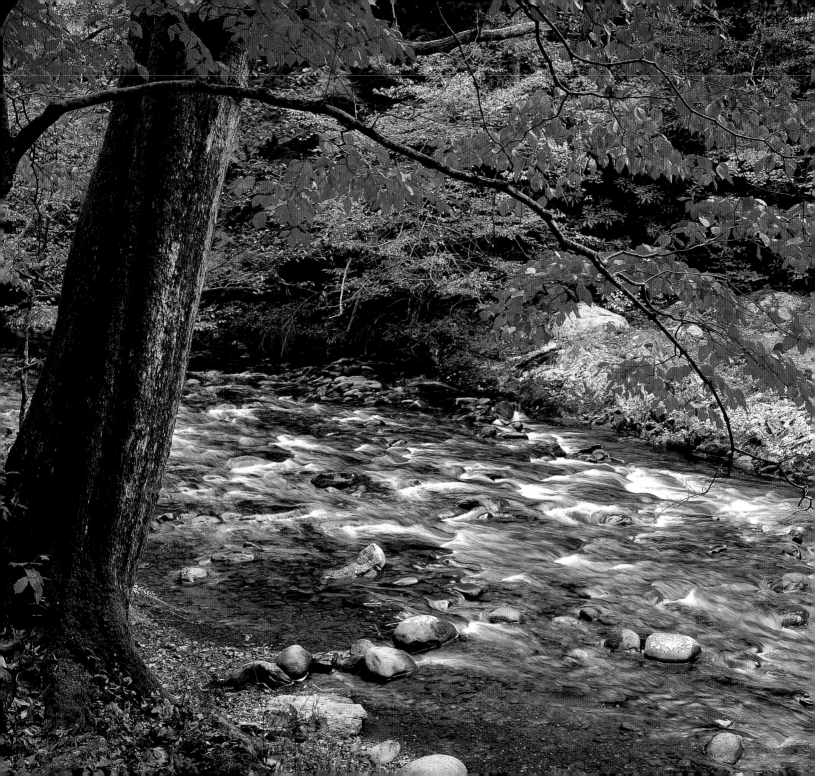

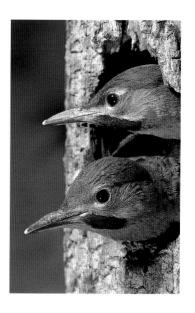

RIGHT: Two young male northern flickers peer from a hollowed tree. The park's diverse forests host six other species of woodpeckers as well.

BELOW: A view from the top of the Chimney Tops. These distinctive outcrops were named for their resemblance to a cabin's stone chimney. The rock is a type of 600-million-year-old slate called Anakeesta.

FACING PAGE: The Little River in autumn. Winding Little River Road follows this quintessential mountain stream for 10 miles through the park.

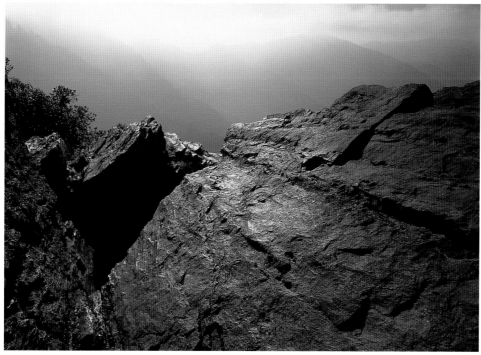

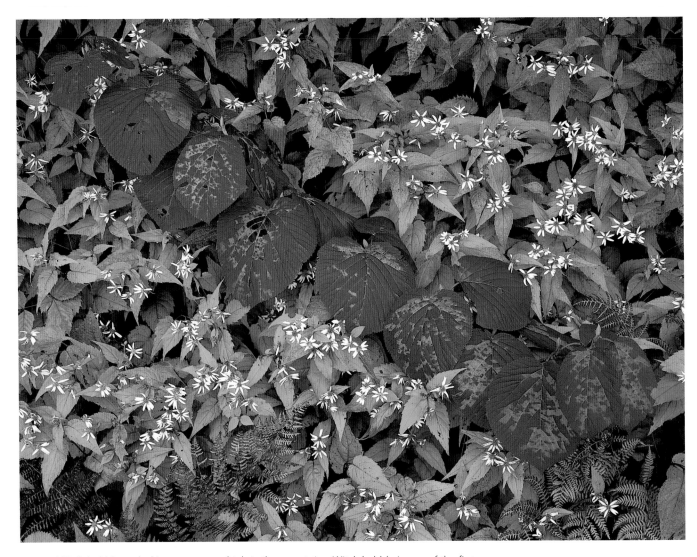

ABOVE: Witch hobble and white asters grow high in the mountains. Witch hobble is one of the first shrubs to exhibit fall color. Its leaves blush crimson as early as late August.

FACING PAGE: Ninety-foot tall Ramsay Cascade is located in the Greenbrier area of the national park. Viewing the falls is earned by hiking four miles on the Ramsay Cascade Trail.

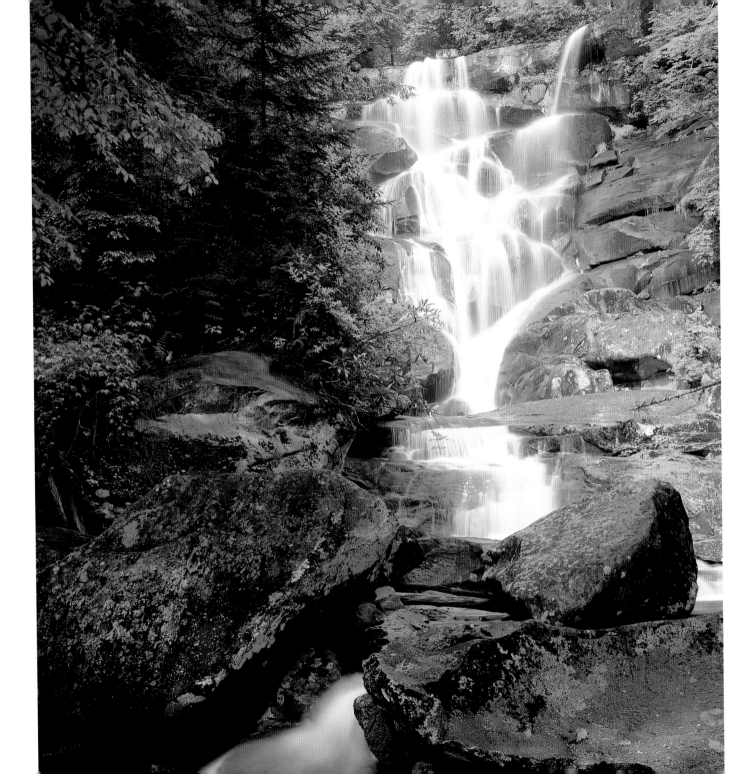

A well-preserved historic church in Cades Cove. Churches, barns, log homes, and a grist mill are all open to the public in this historic district. Besides exploring history, wildlife viewing is a popular activity in the cove.

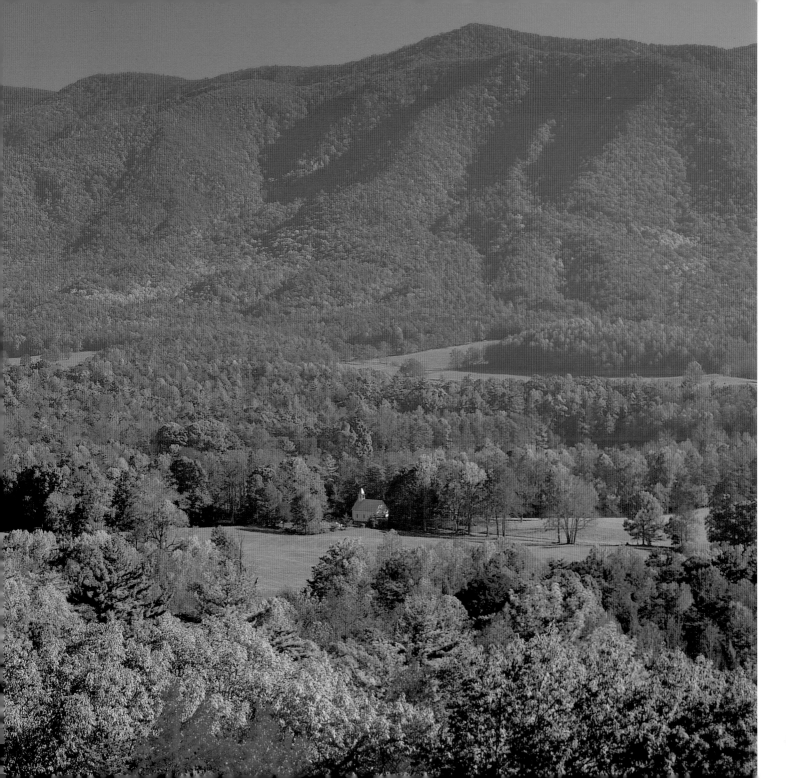

Sunny days and cool nights coax autumn colors to their peak. Their beauty is ephemeral, however, as high winds and rain can quickly strip trees of their delicate fall foliage.

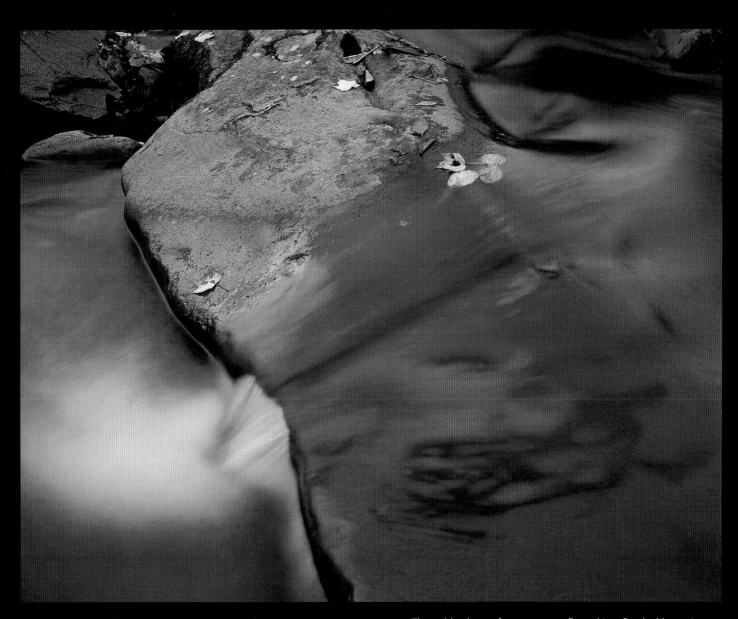

The golden hues of autumn are reflected in a Smoky Mountain stream. Because the headwaters of such streams are protected by the National Park Service, their waters are exquisitely clean.

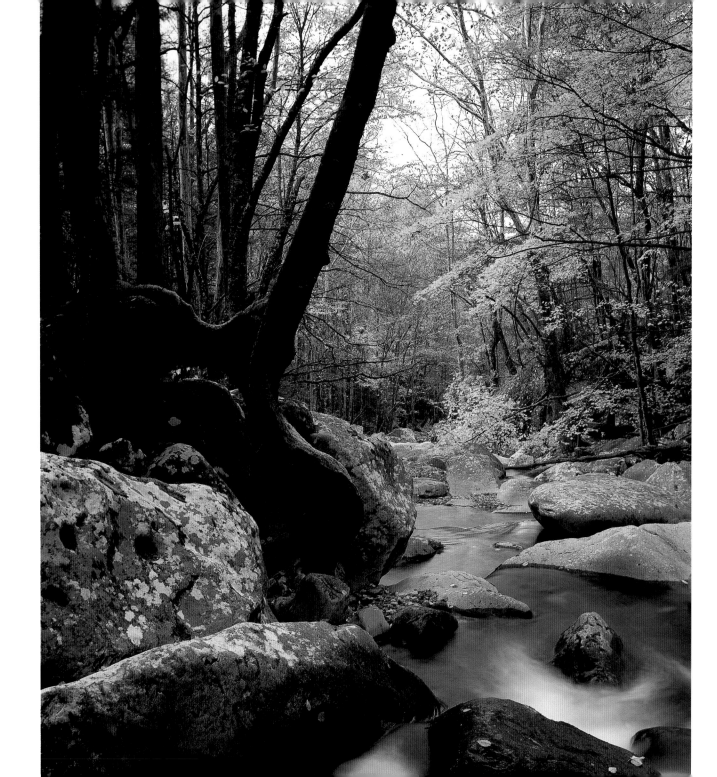

RIGHT: Reaching Alum Cave Bluffs requires a steep, 2.2 mile hike on the Alum Cave Trail. Around the time of the Civil War, saltpeter was mined here for the manufacture of gunpowder.

FACING PAGE: Boulder-strewn mountain streams are a hallmark of the Great Smoky Mountains. Some 50 species of fish live in park waters along with as many as 1,500 types of aquatic insects.

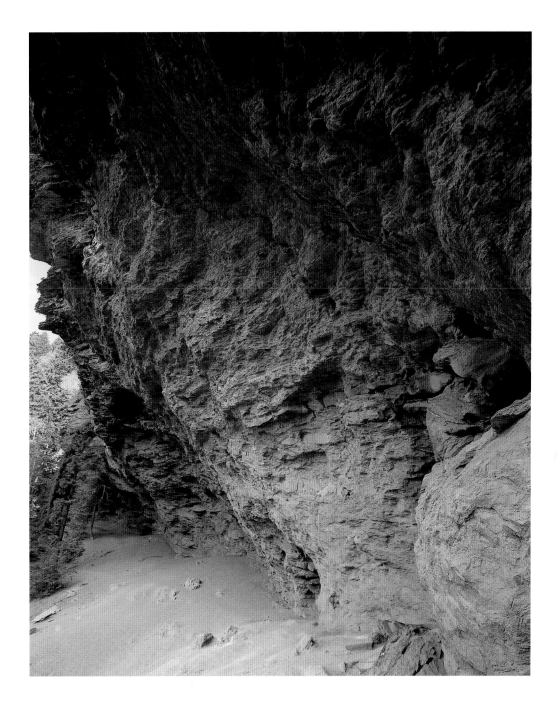

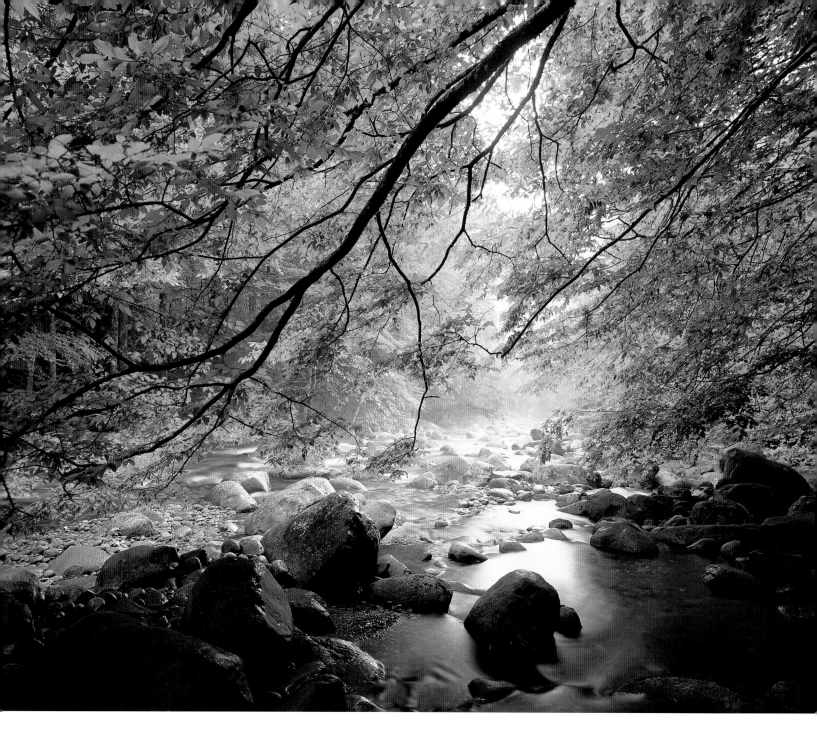

RIGHT: Coneflower thrives in wet areas and long mountain streams. The plant stands up to five feet tall and its flowers can be enjoyed from late summer into October.

BELOW: White-tailed deer fawns are born in June. Deer were nearly eliminated from the Smoky Mountains before the park was established in 1934. Today they are a common sight, especially in Cades Cove.

FACING PAGE: The Middle Prong of the Little Pigeon River. The headwaters of this stream are excellent habitat for brook trout, the only trout native to the southern Appalachian Mountains.

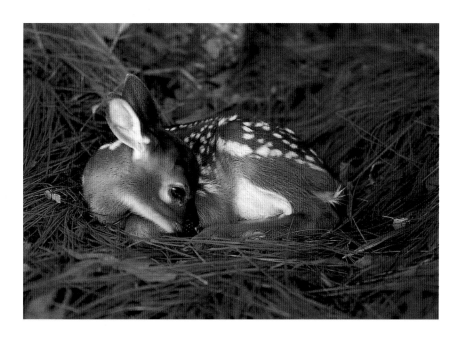

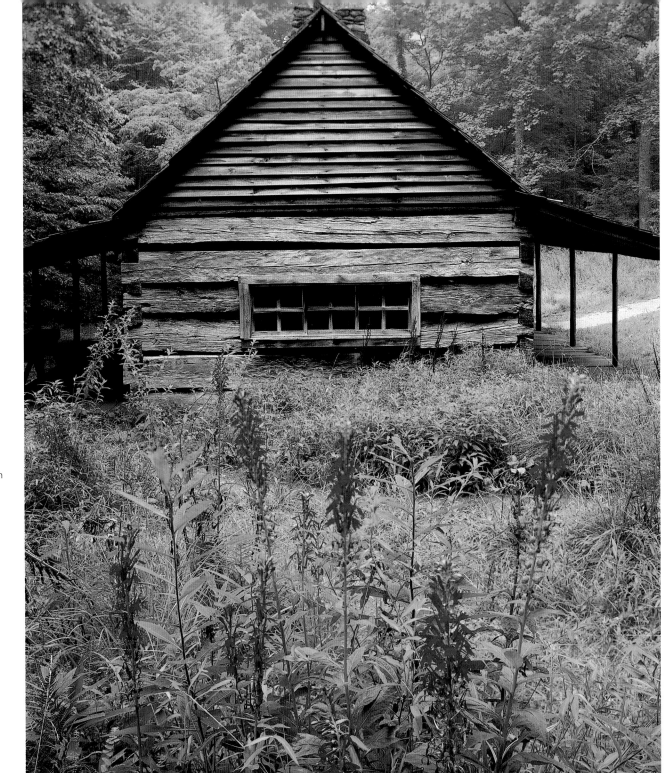

The Ogle Cabin is to be seen along the Roaring Fork Nature Trail.

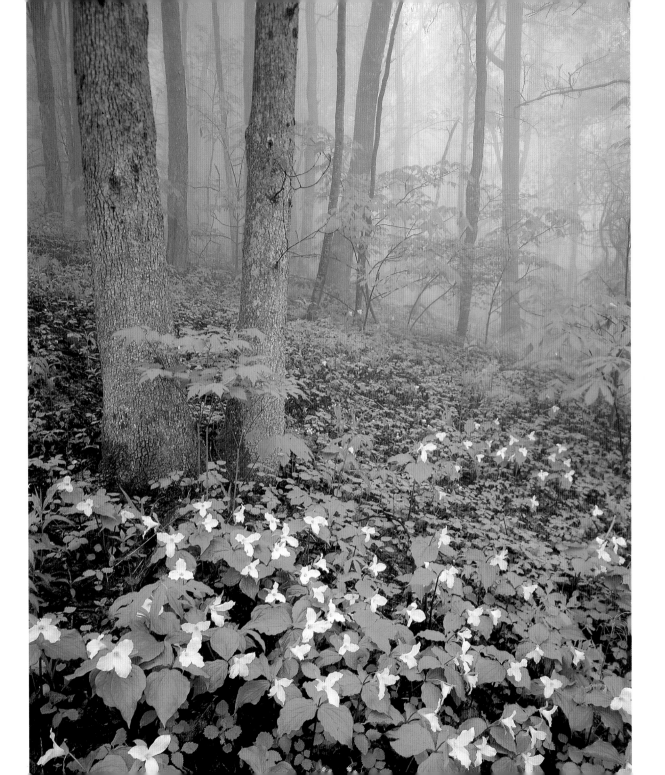

April is paradise for wildflower lovers in the park. Here white trilliums thrive in the rich soils of a second-growth forest.

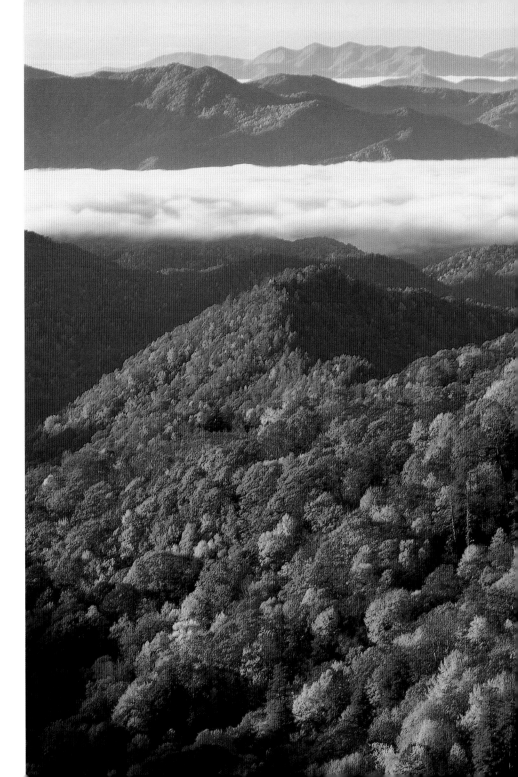

Shot Beech Ridge and Deep Creek Valley from Newfound Gap Road. Autumn days in the Smokies are typically sunny and remarkably clear, perfect conditions for hikers, sight-seers, and photographers.

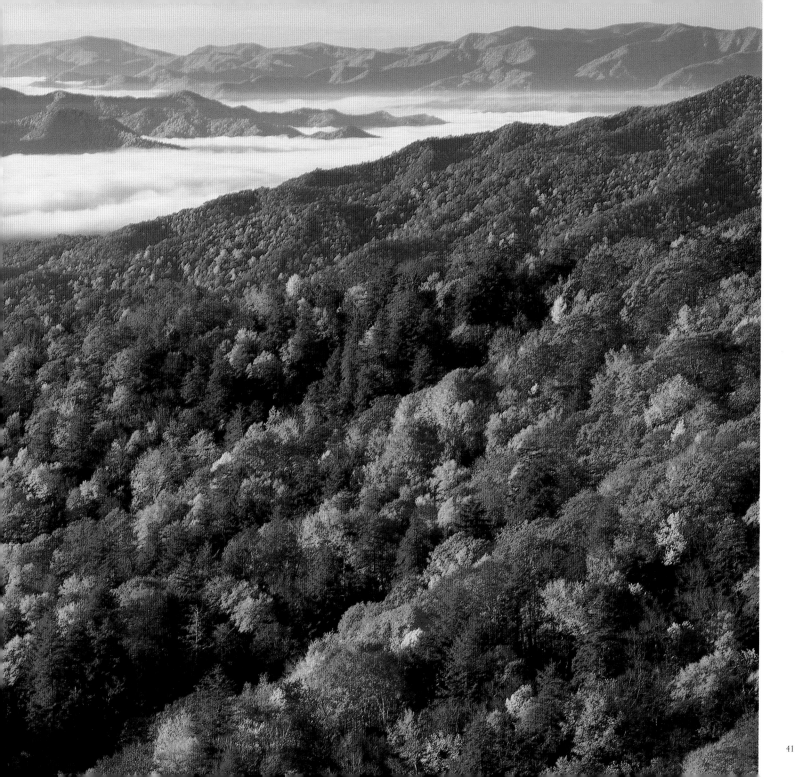

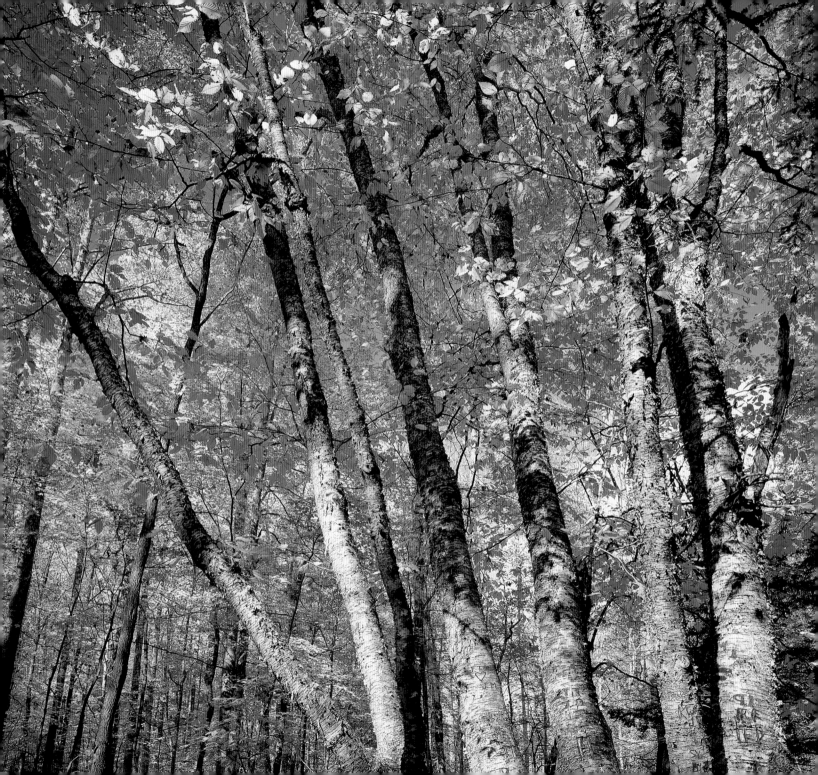

RIGHT: The Little Pigeon River in the Greenbrier area of the park. The massive boulders in Smoky Mountain streams fall from high cliffs and slowly migrate to river valleys over thousands of years.

FACING PAGE: The best fall colors are usually found between elevations of 2,000-4,000 feet, where American beech, birch, sourwood, and maple trees are abundant.

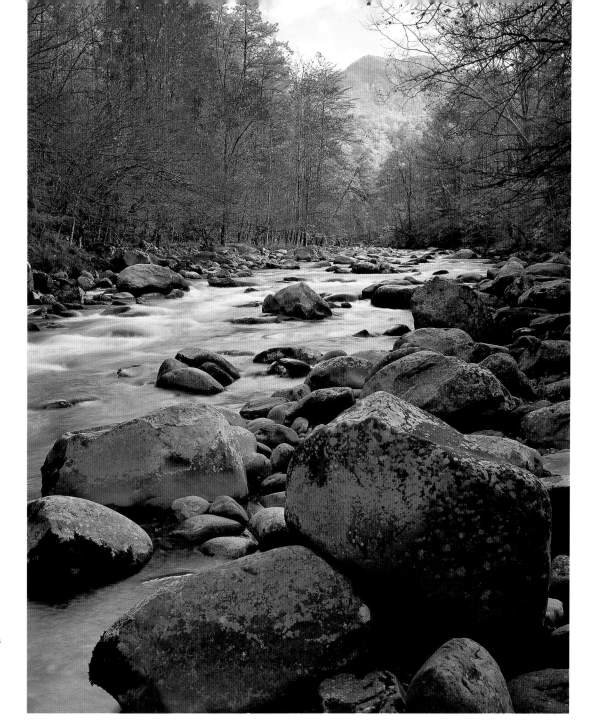

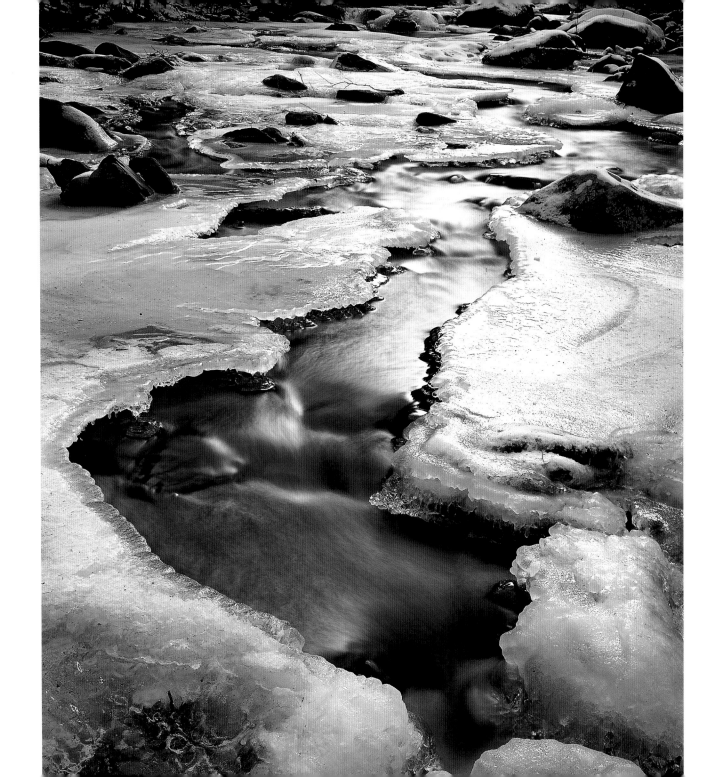

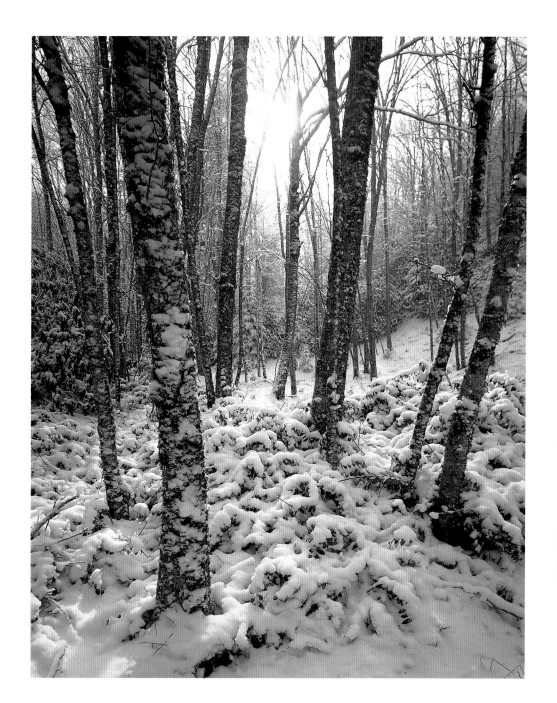

LEFT: Fresh snow in a northern hardwood forest along the Alum Cave Trail. The popular trail leads past Alum Cave Bluffs to the summit of Mount Le Conte at 6,593 feet.

FACING PAGE: The Oconaluftee River in winter. Trout and aquatic insects remain active in park streams during winter, though their metabolisms are slowed by the cold water temperatures.

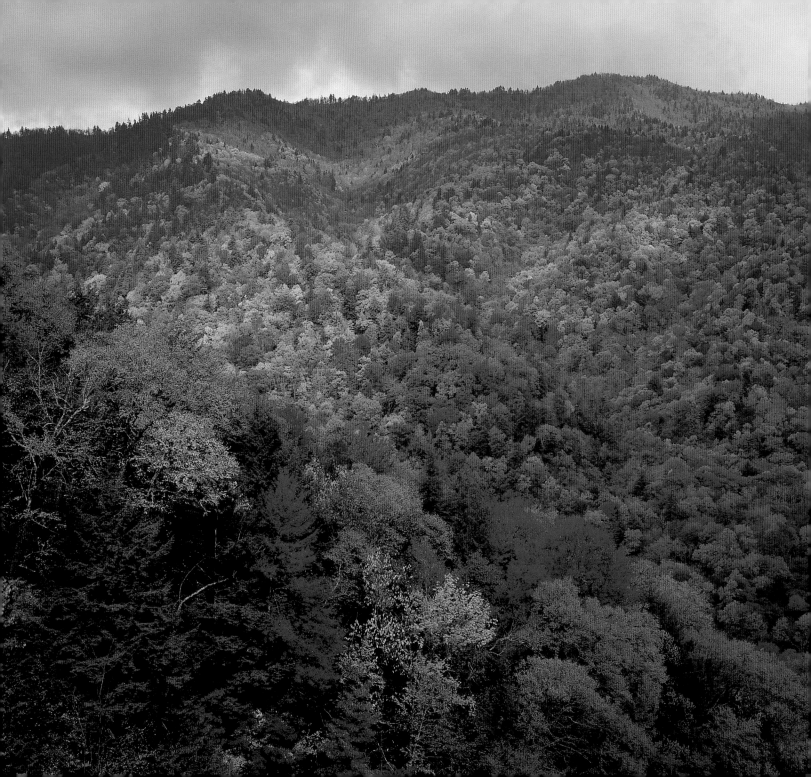

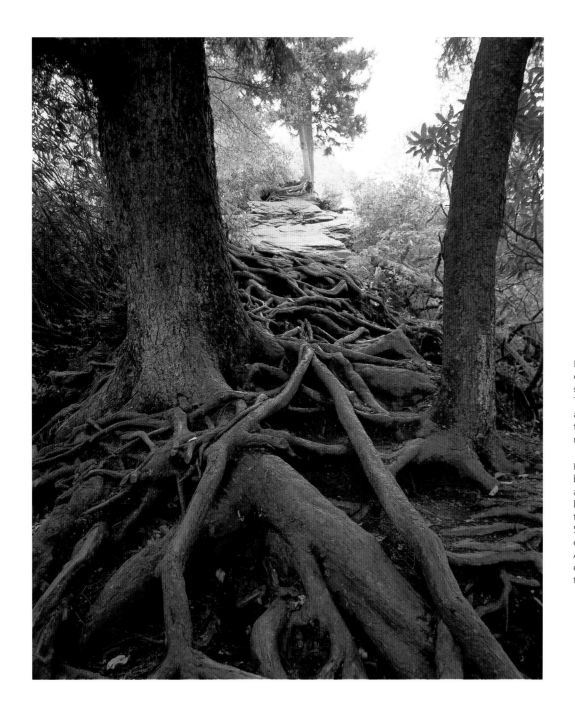

LEFT: A tangle of exposed roots near the summit of Chimney Tops Trail. Soils are often thin along ridgetops, causing trees to spread their roots horizontally.

FACING PAGE: Fall colors below Newfound Gap and Charlies Bunion. Deciduous hardwood trees dominate the Smoky Mountains below elevations of 4,500 feet. At the higher elevations, evergreen spruce and fir trees reign.

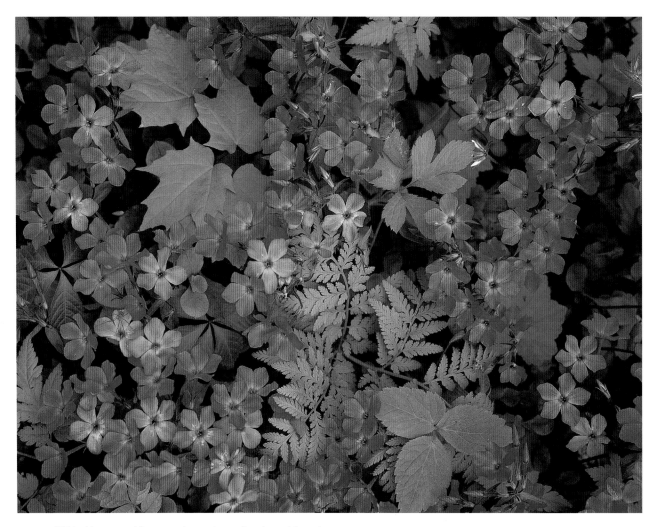

ABOVE: Wild phlox, wood fern, maple, and sassafras form this early sum-
mer collage. Researchers estimate that some 100,000 different types of
plants and animals inhabit the Great Smoky Mountains.

FACING PAGE: Sunrise from Clingmans Dome. An observation tower atop
this 6,643 foot peak offers panoramic views of the Smokies and
adjacent mountain ranges.

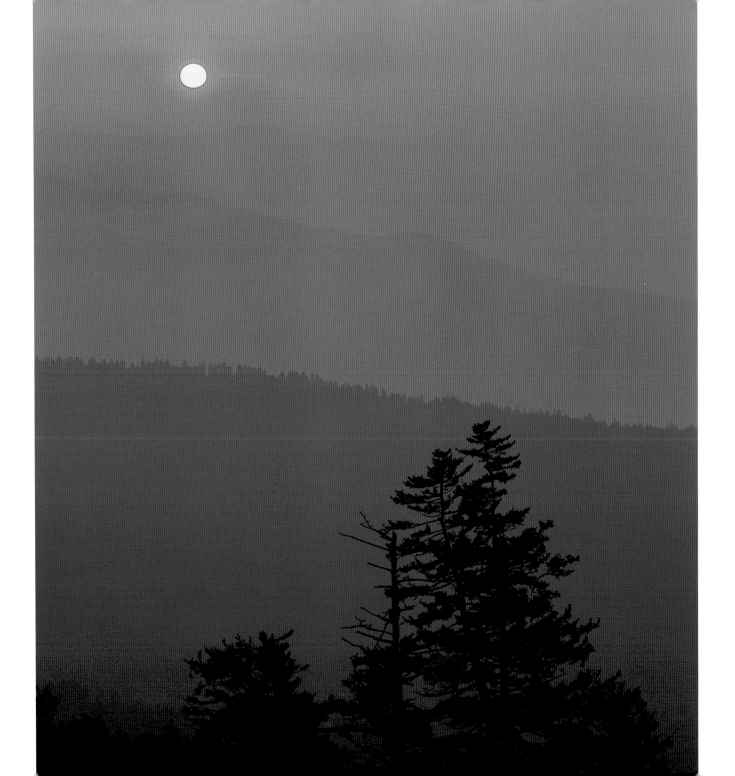

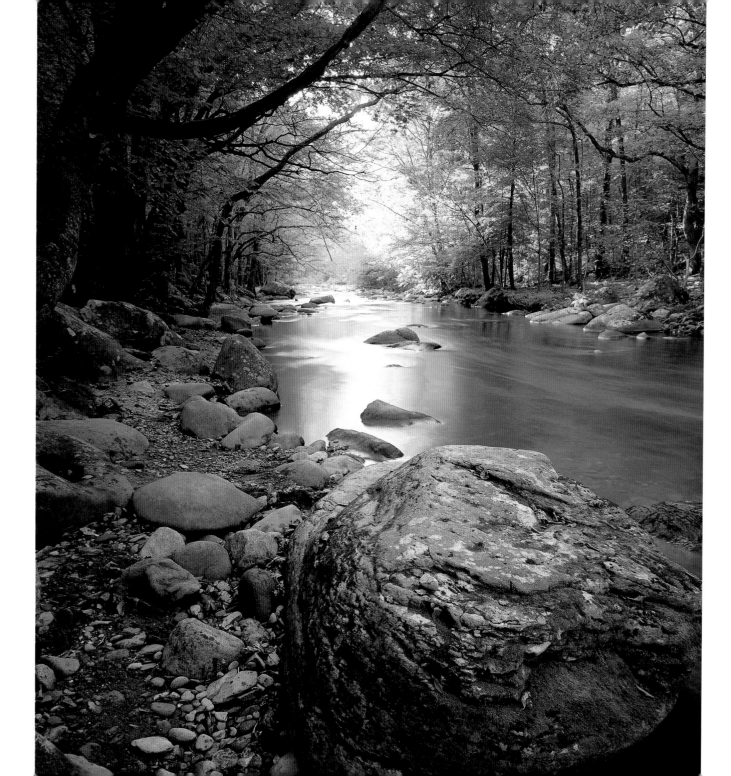

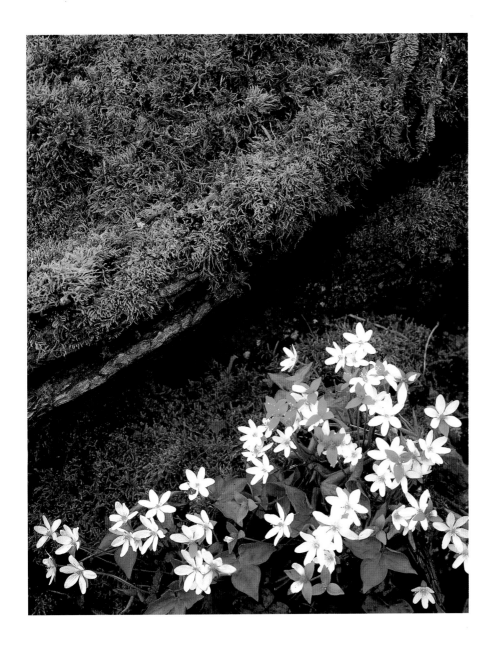

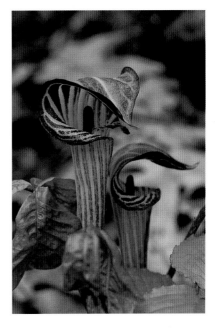

ABOVE: Jack-in-the-pulpit can be found in moist woods throughout the park. In the lowlands, they start blooming in March. High elevation individuals bloom into June.

LEFT: Hepatica's pink and white flowers open as early as February if the weather is mild.

FACING PAGE: Little River is really one of the larger rivers in Great Smoky Mountains National Park. It is born near the Appalachian Trail and is favored by anglers in pursuit of rainbow and brown trout.

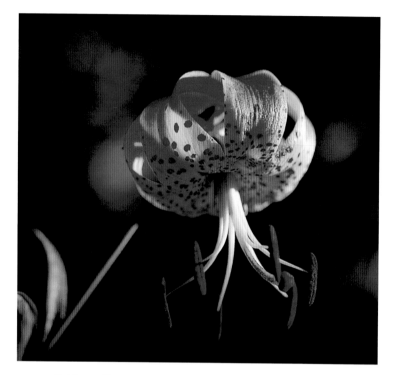

ABOVE: Turk's cap lily is a common wildflower in the Smokies, especially at the higher elevations. The plant grows to eight feet tall and its flowers bloom from late summer into September.

RIGHT: A giant sycamore tree grows along the banks of the Oconaluftee River. The Oconaluftee flows out of the national park into the Cherokee Indian Reservation, home of the eastern band of the Cherokee tribe.

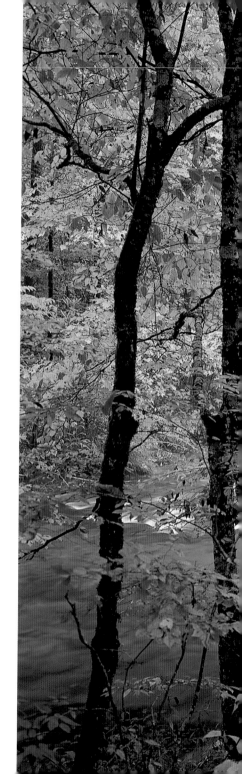

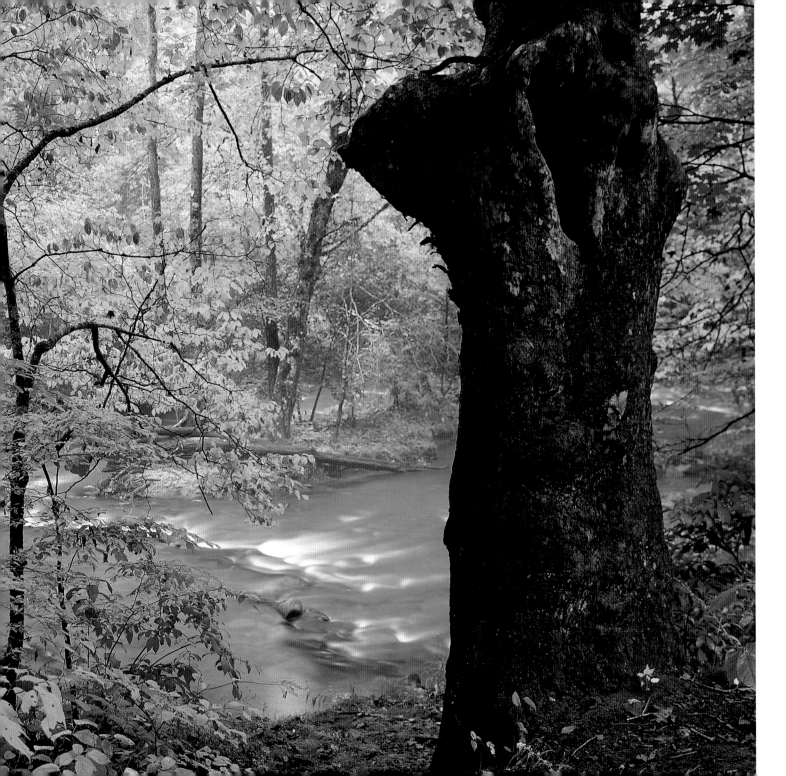

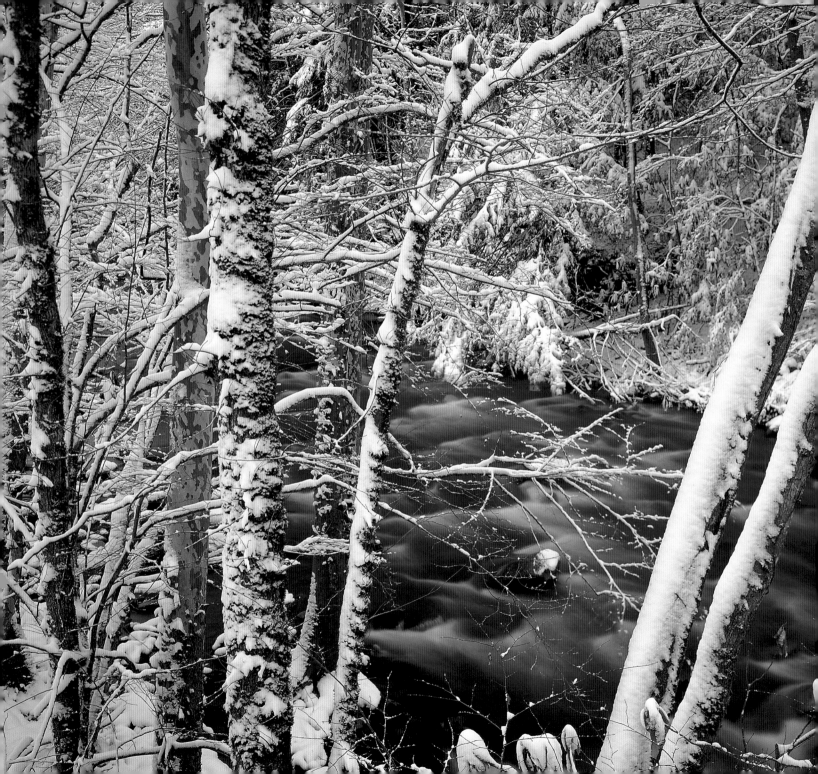

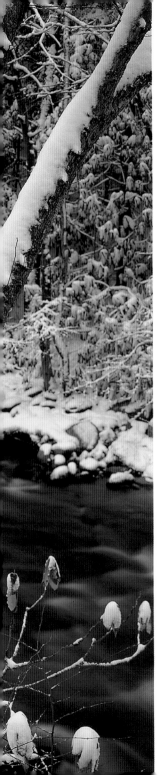

LEFT: Winter is a beautiful time to visit the Great Smoky Mountains. Snow falls infrequently in the valleys, but can reach depths of two feet or more at the higher elevations.

BELOW: View of oncoming storm from Clingmans Dome. Afternoon downpours keep the Smokies lush and verdant throughout the summer.

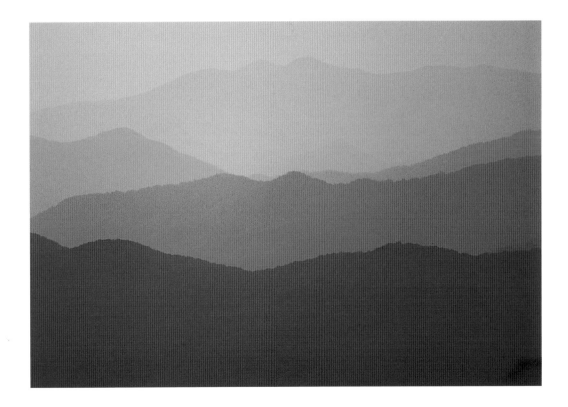

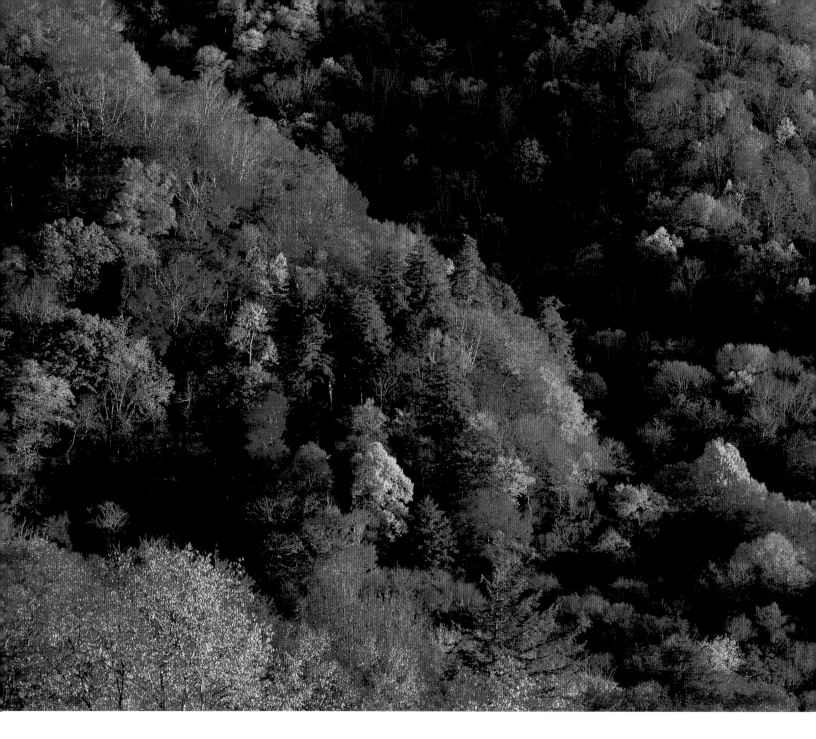

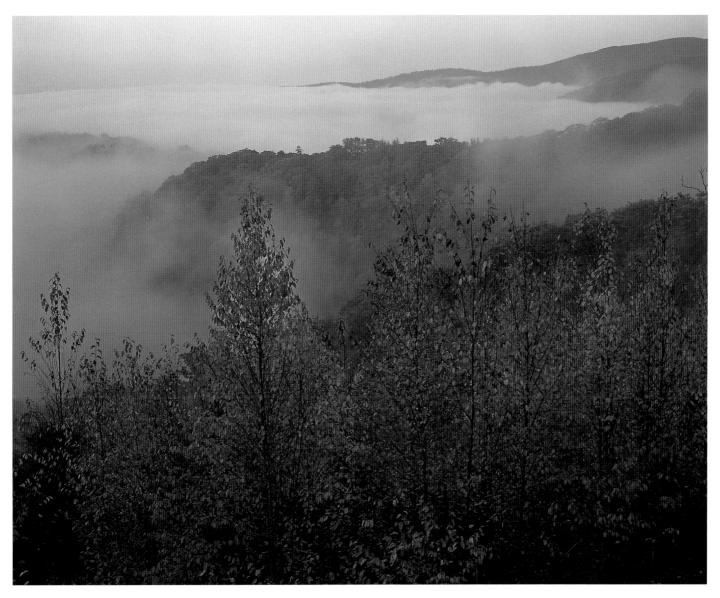

ABOVE: Looking toward Clingmans Dome from Newfound Gap Road at dawn.

FACING PAGE: The first hints of autumn color show along the ridgetops as early as mid-September. The peak of fall color usually occurs at the lower and middle elevations during the last two weeks of October.

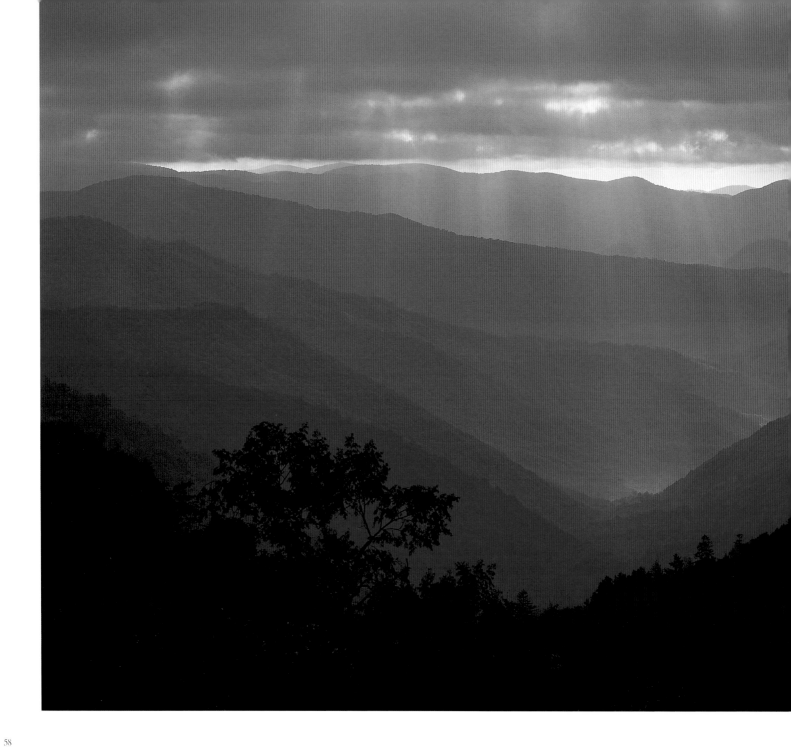

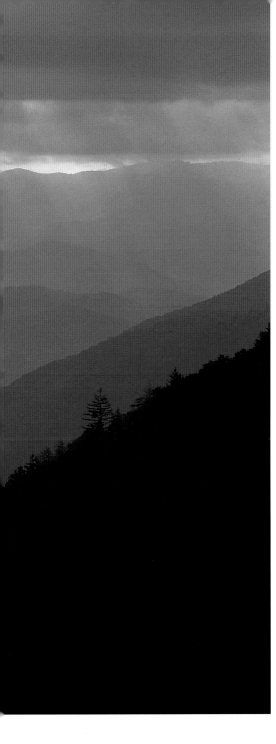

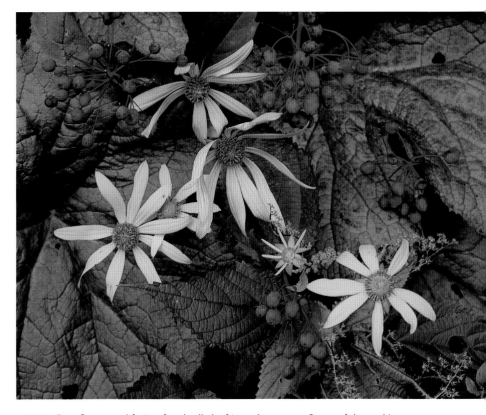

ABOVE: Coneflower and fruits of umbrella leaf in early autumn. Some of the park's most colorful wildflowers bloom in late summer and fall.

LEFT: View from Newfound Gap toward Richland Mountain. Beyond the park borders, Nantahala and Pisgah national forests protect additional southern Appalachian mountain land.

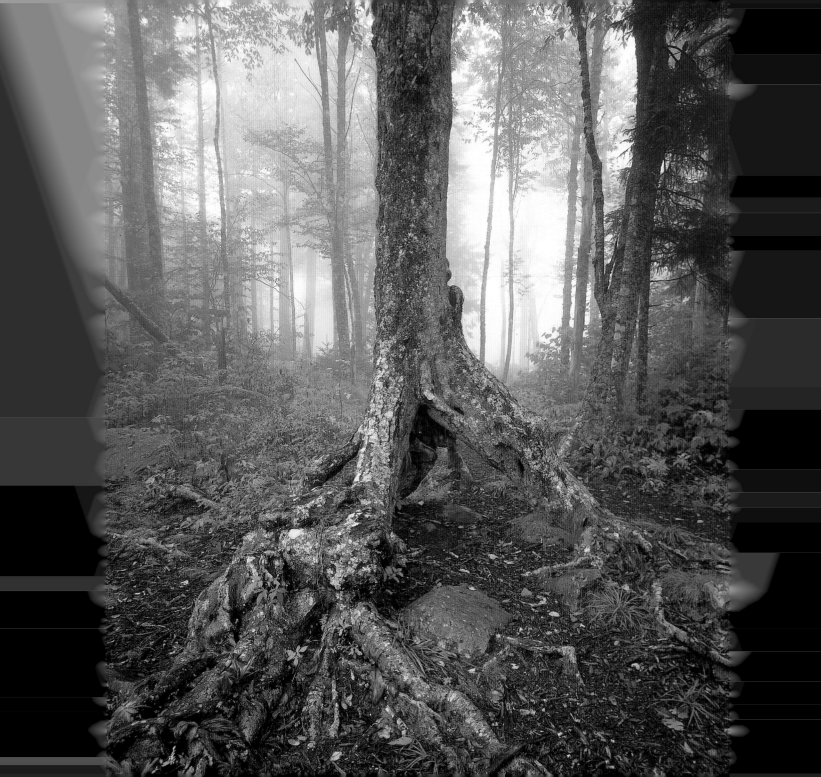

RIGHT: Pink lady's slipper orchids are a delight to find. They bloom in dry pine-oak woods from April into July.

FACING PAGE: Yellow birch trees sometimes grow into this stilted form. Seeds sprout atop fallen logs and send their roots down both sides. When the old log rots away, it leaves the birch tree standing on "stilt" roots.

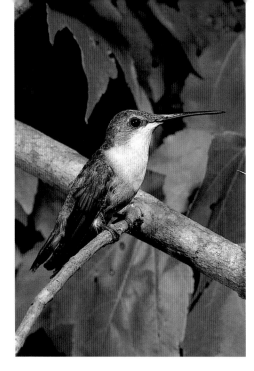

ABOVE: Ruby-throated hummingbirds find plenty of nectar among the park's hundreds of species of wildflowers. Cardinal flower and Catawba rhododendron are two of the bird's favorites.

RIGHT: A slowly decaying American chestnut log provides shelter for white trillium. Chestnut trees in the southern Appalachian Mountains were devastated by a non-native blight during the first half of the 20th century.

FACING PAGE: The hike to Indian Creek Falls begins near Deep Creek Campground. It is a pleasant, relatively easy walk of less than two miles roundtrip.

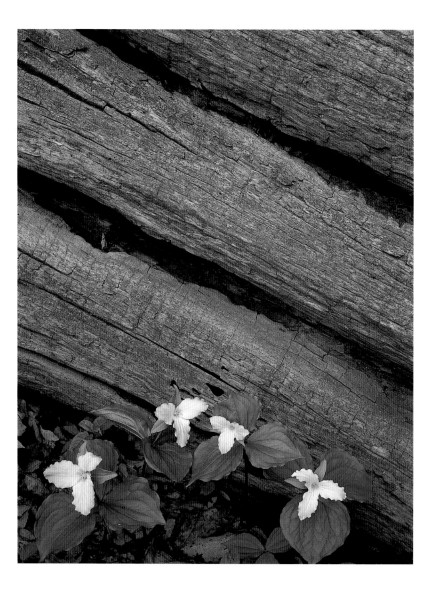

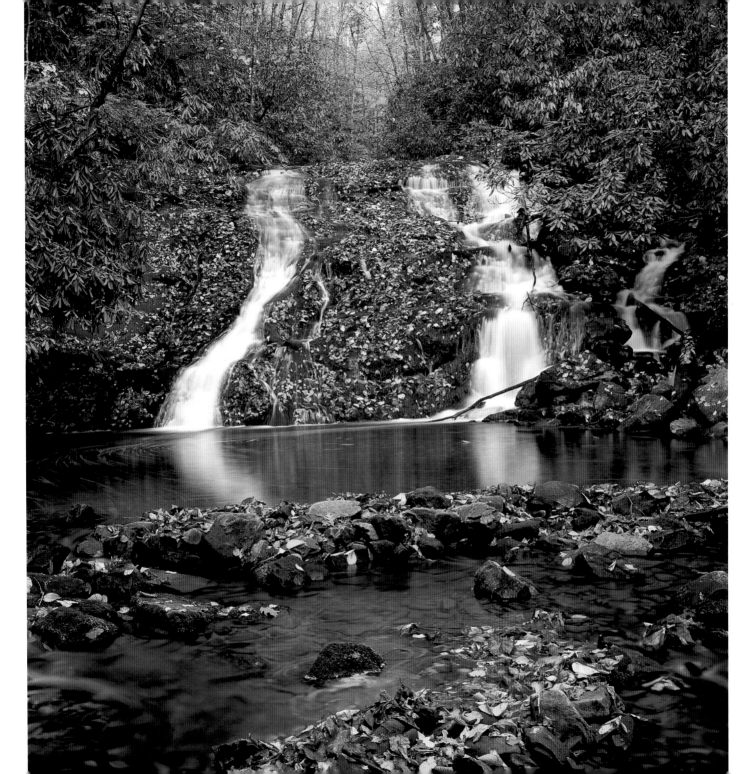

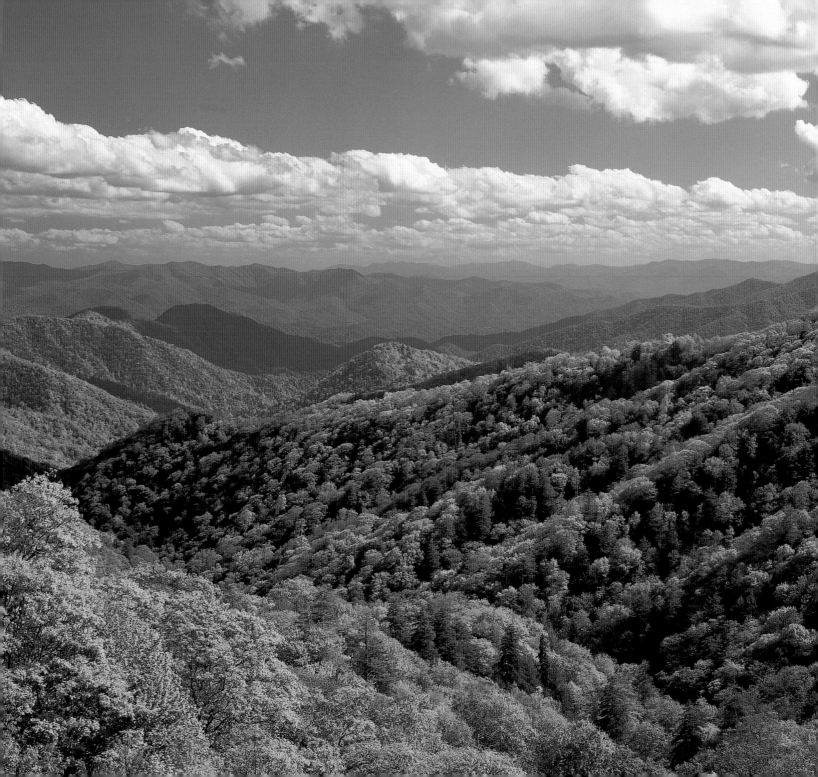

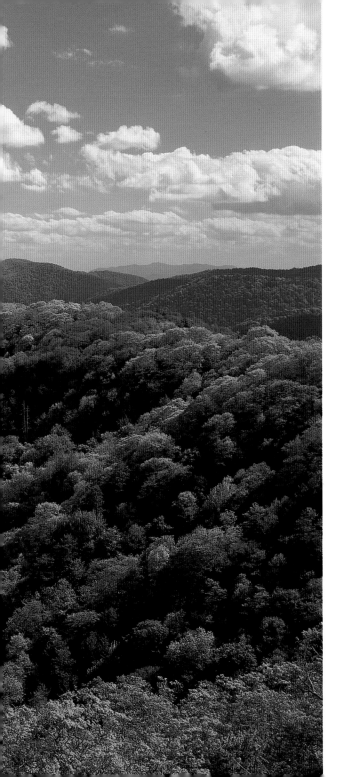

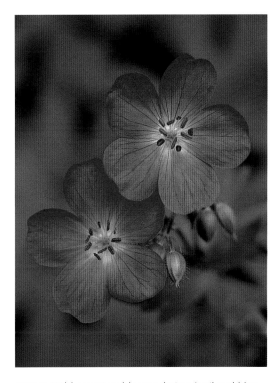

ABOVE: Wild geranium blooms during April and May and is common below elevations of 4,000 feet. The plant stands from 1 to 2½ feet tall.

LEFT: Respectably-sized mountains, plenty of rainfall, and a temperate climate combine to support abundance and diversity in Great Smoky Mountains National Park. A drive from Gatlinburg to Clingmans Dome has been likened to a trip from Tennessee to Maine in terms of the types of forest ecosystems encountered.

RIGHT: An unnamed cascade along the Rainbow Falls Trail near Gatlinburg. Such waterfalls help enrich Smoky Mountain streams with oxygen.

FACING PAGE: White trillium in a grove of tuliptrees. Spring wildflowers carpet the forest floor before deciduous trees unfurl their leaves.

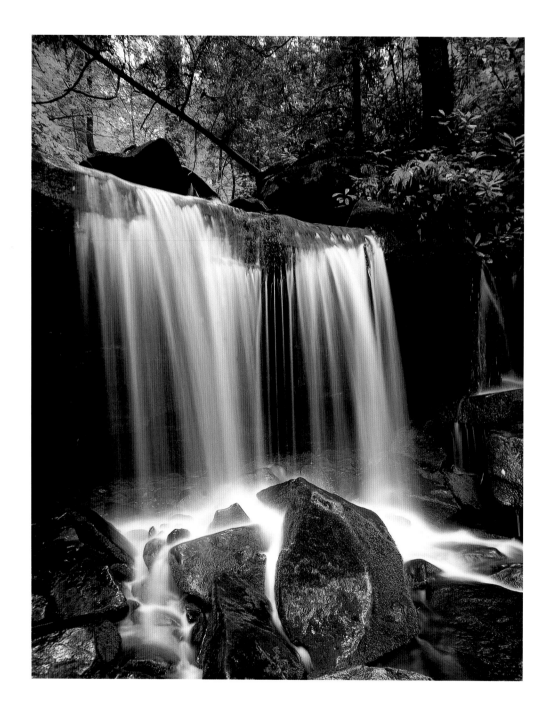

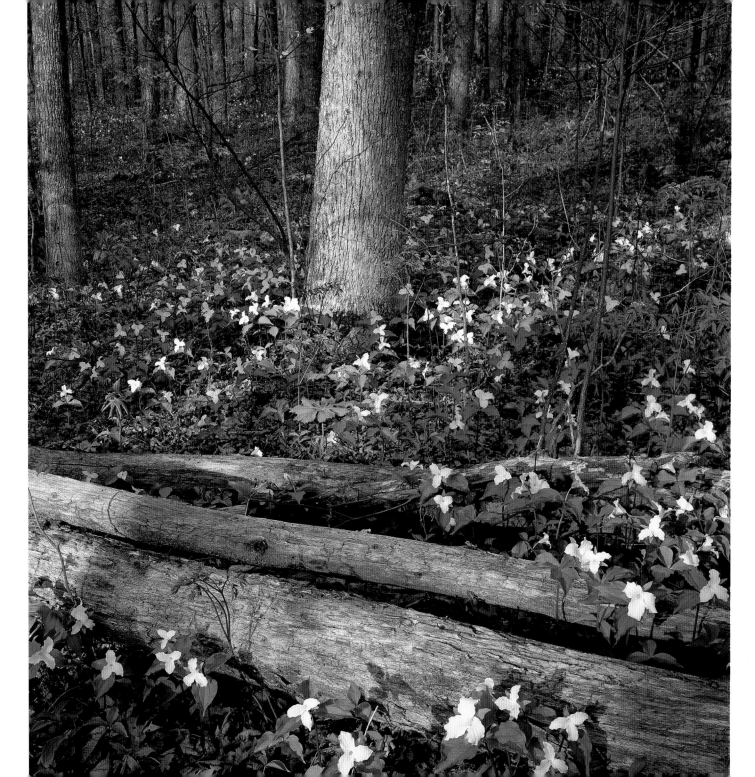

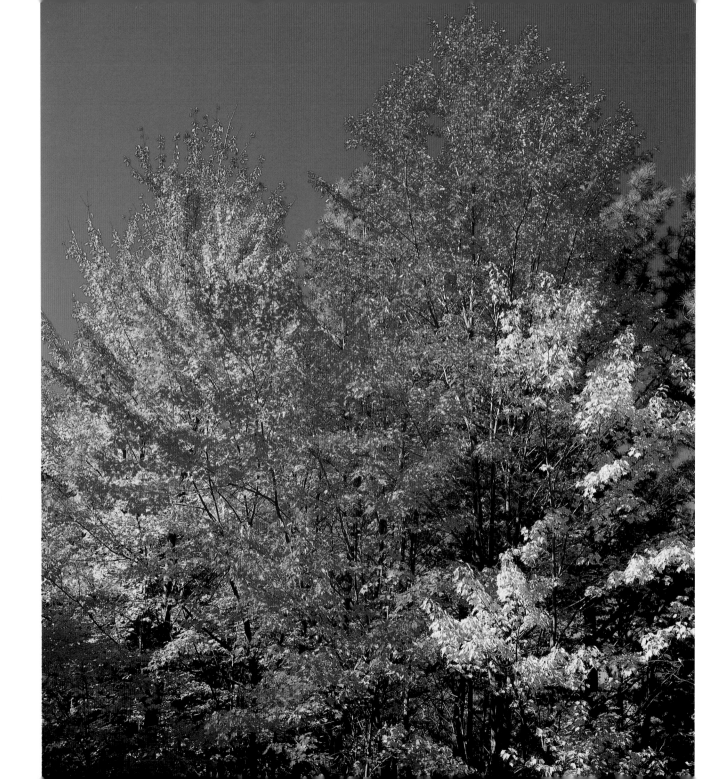

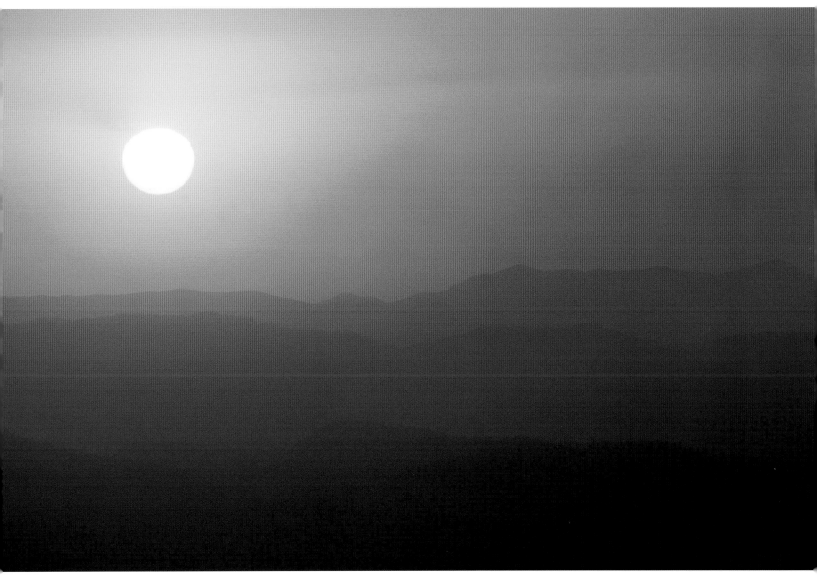

ABOVE: The Great Smokies are ancient mountains rounded by water and ice. Most of the rock that makes up the backbone of the range was formed over 600 million years ago.

FACING PAGE: Ninety-nine species of native trees live in Great Smoky Mountains National Park. Together they create an autumn finale that attracts over a million visitors to the area each October.

RIGHT: Flowering dogwood trees produce copious quantities of bright red berries that persist into winter. The berries are a favorite food for squirrels and dozens of species of birds.

FACING PAGE: A waterfall along the West Prong of the Little Pigeon River. Heavy rains and snow in the high country and thousands of trickling springs keep park streams flowing robustly throughout the year.

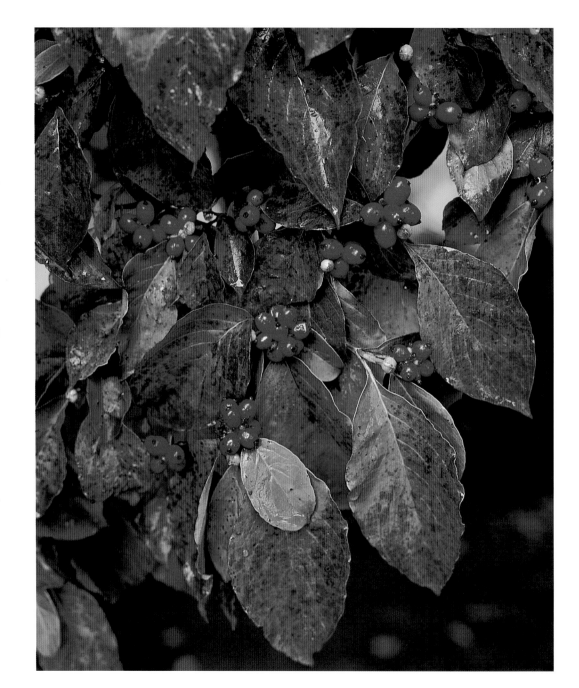

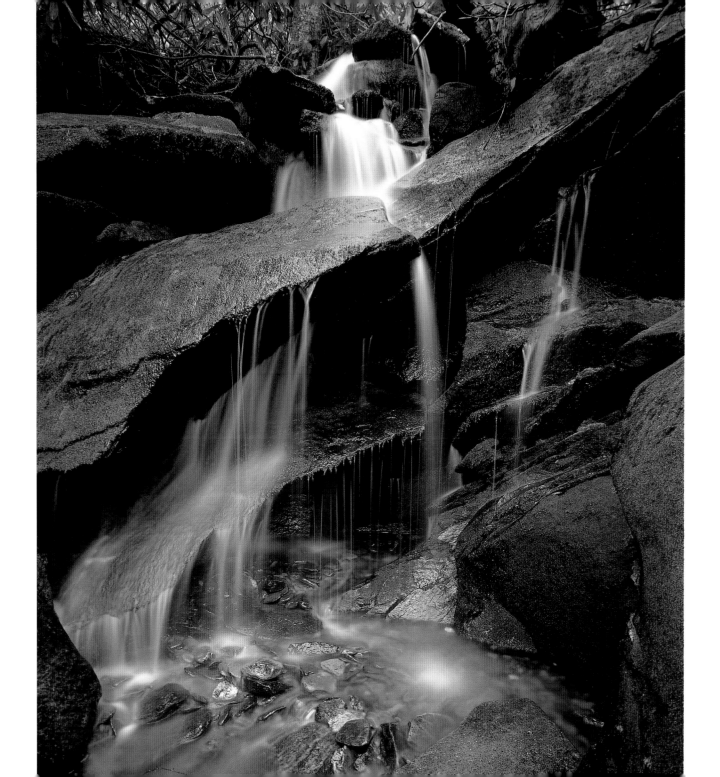

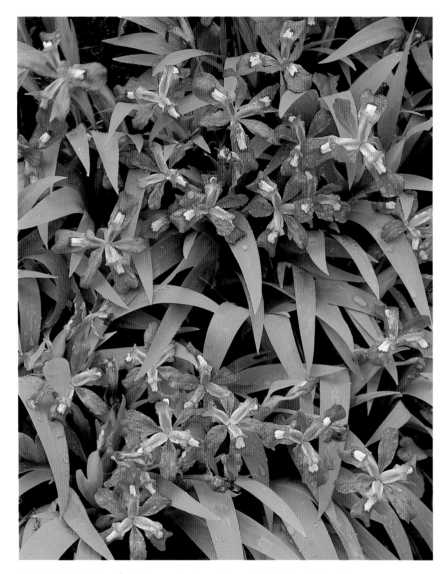

ABOVE: Crested dwarf iris blooms in dense clumps in April and May. It is a common wildflower, especially at the lower elevations.

RIGHT: View of the Smokies from Clingmans Dome Road. At least 16 peaks in the Great Smokies rise to over 6,000 feet in elevation.

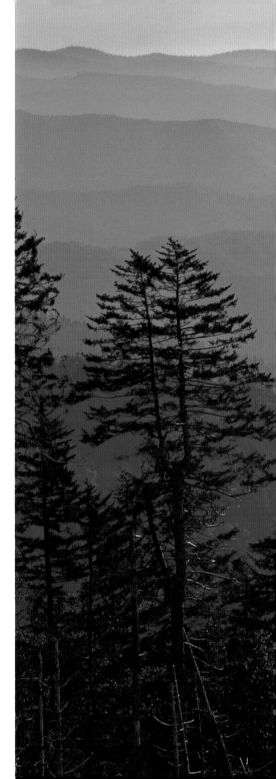

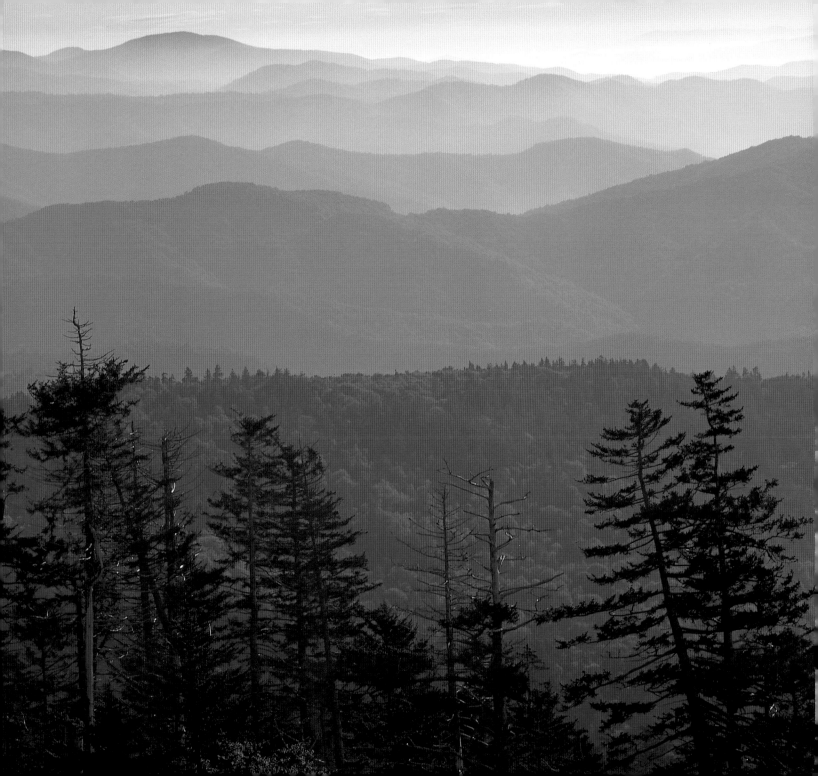

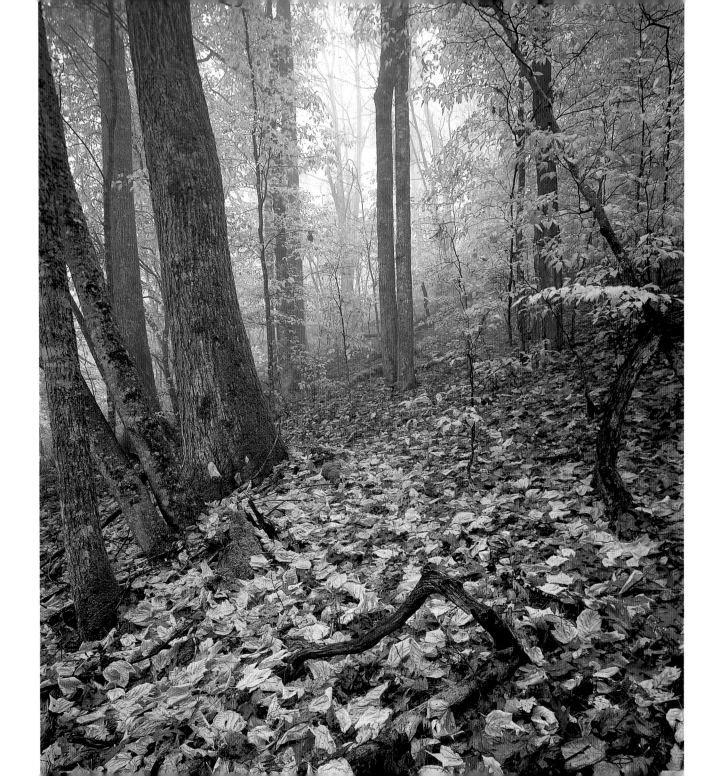

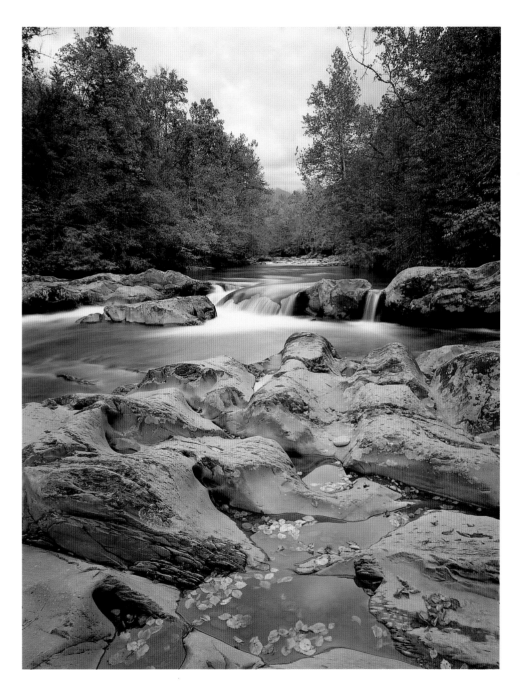

LEFT: During the 19th and early 20th centuries the Little Pigeon River powered many small grist mills as it flowed past small mountain farms.

FACING PAGE: The upper section of Thomas Divide Trail can be spectacular in autumn. American beech, yellow birch, mountain maple, and other trees show splendid colors in early October.

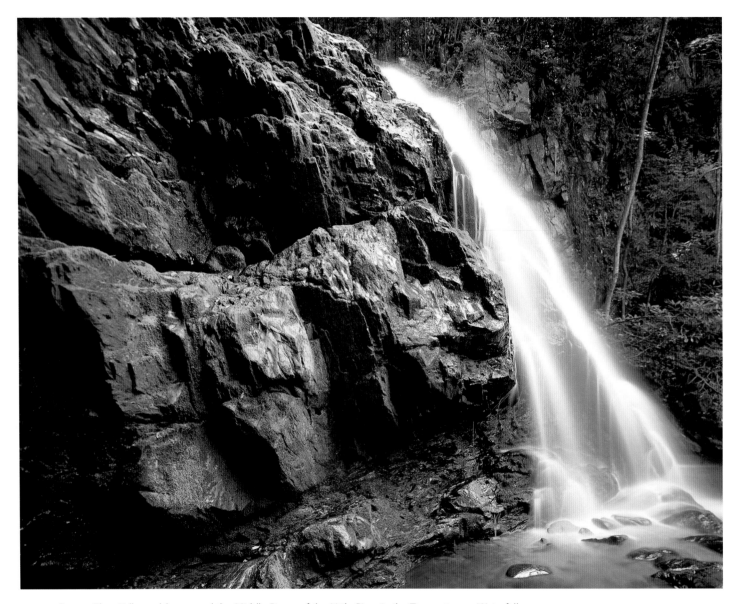

ABOVE: Spruce Flats Falls tumbles toward the Middle Prong of the Little River in the Tremont area. Waterfalls are usually formed at the junction of different geological rock types.

FACING PAGE: The Noah "Bud" Ogle cabin and farmstead are located on Cherokee Orchard Road near Gatlinburg. The historic site features a water-powered "tub" mill and a self-guiding nature trail that wends through the old farm.

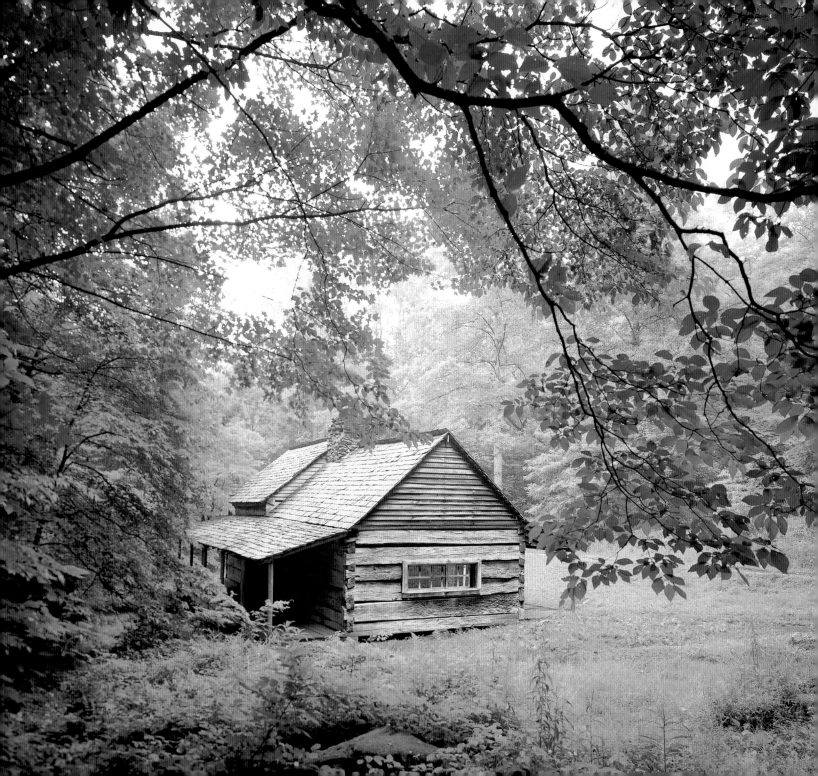

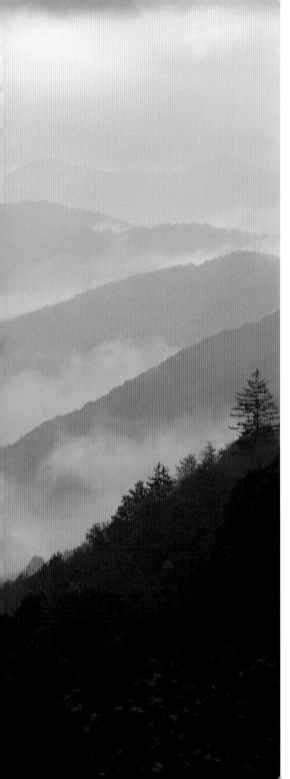

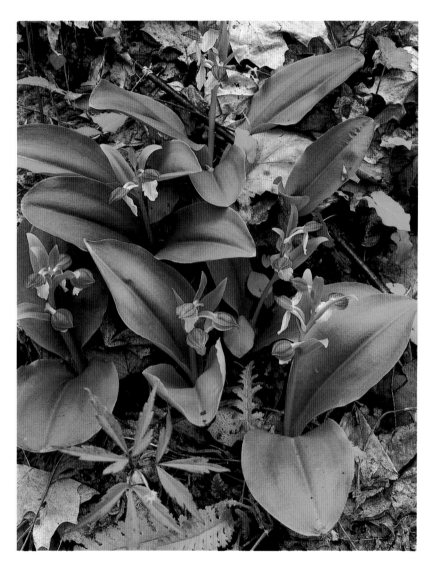

ABOVE: Showy orchis decorates the forest floor in April and May. The 5- to 10-inch-tall plant is common below elevations of 4,500 feet.

LEFT: Sunrise from Newfound Gap. Highway 441 crosses the Great Smoky Mountains here. Previously, a wagon road crossed the mountain range at nearby Indian Gap, but a lower, "new-found" gap (or pass) was located when the modern road was built.

Born in Asheville, North Carolina, George Humphries spent most of his early life in the mountain towns of Black Mountain and Brevard and, except for eight years, has always lived in North Carolina. Today Humphries lives in Asheville with his wife, Linda, daughter Katie, and sons Sean and Weston. Humphries' involvement with nature photography began in 1980, when his wife surprised him with a camera, prior to an eight-week sojourn across Canada and the United States. His photographs have appeared in numerous national, regional, state and local publications, including *Audubon, Outdoor Photographer, Browntrout, Graphic Arts,* and *Wildlife of North Carolina.* In addition, his work has appeared in several books, including, *North Carolina: Images of Wildness, A North Carolina Christmas, Along the Blue Ridge Parkway, North Carolina Reflections,* and most recently, *North Carolina Wildflowers.* In 1996, Humphries was selected as artist affiliate for Brevard College.

Steve Kemp is the author of *Trees of the Smokies* and has written articles for *Outdoor Life, Outside, National Parks, Outdoor Photographer,* and the Discovery Channel guidebook series. He worked as a seasonal park ranger in Yellowstone and Denali national parks and has been publications director for Great Smoky Mountains Natural History Association since 1987. (Photo by Don McGowan)